BIG BOOK OF
SILHOUETTES

BIG BOOK OF SILHOUETTES

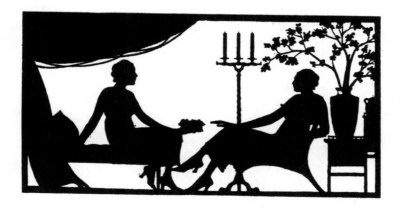

Selected and Arranged by
CAROL BELANGER GRAFTON

DOVER PUBLICATIONS, INC.
Mineola, New York

BIG BOOK OF SILHOUETTES

Bibliographical Note

Big Book of Silhouettes is a new work, first published by
Dover Publications, Inc., in 2000.

DOVER *Pictorial Archive* SERIES

International Standard Book Number

ISBN-13: 978-0-486-40701-2
ISBN-10: 0-486-40701-2

www.doverpublications.com

PUBLISHER'S NOTE

NAMED FOR ETIENNE DE SILHOUETTE (1709–67), the controller-general of France, who amused himself by cutting portraits from paper, the silhouette, a portrait or scene depicted in outline filled in solid, captures the essence of its subject with a minimum of detail. Although strictly speaking, a silhouette is cut from paper, similar illustrations can be traced as far back as Paleolithic cave paintings and can be found in the pottery decoration of the Mesopotamians, the Greeks, and the Etruscans. In the East, the Chinese were producing cut-paper designs as far back as the Tang dynasty (618-907). Shadow portraits flourished in mid-18th- to mid-19th-century Europe and America, first painted on a variety of surfaces, then, as paper became more generally available, cut freehand or from traced lines. Such shadow paintings were a staple of the popular periodicals of the time and later, in the teens and twenties, were widely used as advertising spot illustrations. Their crisp, bold, graphic appeal has enabled them to maintain their popularity today.

Carol Belanger Grafton has collected over 1,700 silhouettes drawn from a variety of 19th- and early 20th-century sources for this volume, offering a wealth of copyright-free illustrations that can be used for crafts or graphic projects. The material has been organized into categories to make it even easier to use.

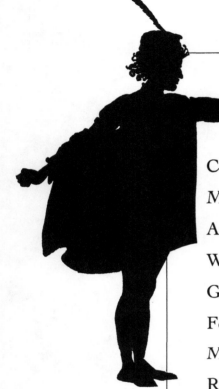

CONTENTS

Children / 1

Music and Dance / 16

Angels and Cherubs / 21

Women / 22

Gardening / 37

Food and Drink / 38

Men / 44

Romance / 66

Sports and Recreations / 68

Animals / 74

Nautical / 87

Reading and Writing / 88

Transportation / 92

Groups and Scenes / 96

Nature / 106

Military and Weapons / 111

Witches / 114

Fantasy Figures / 115

Ornaments / 116

Miscellaneous / 117

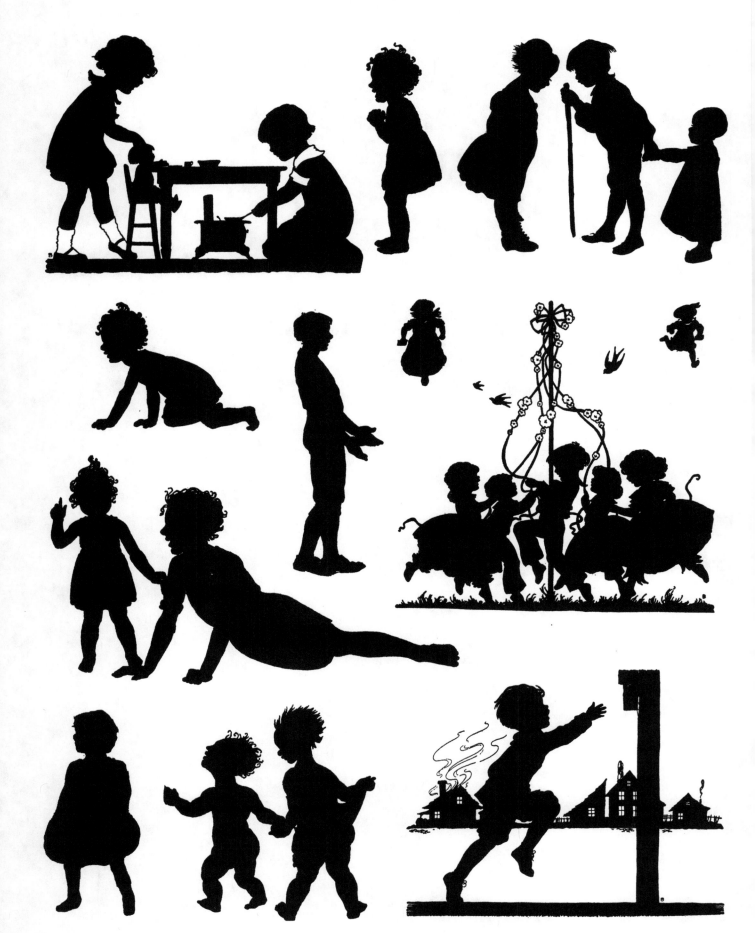

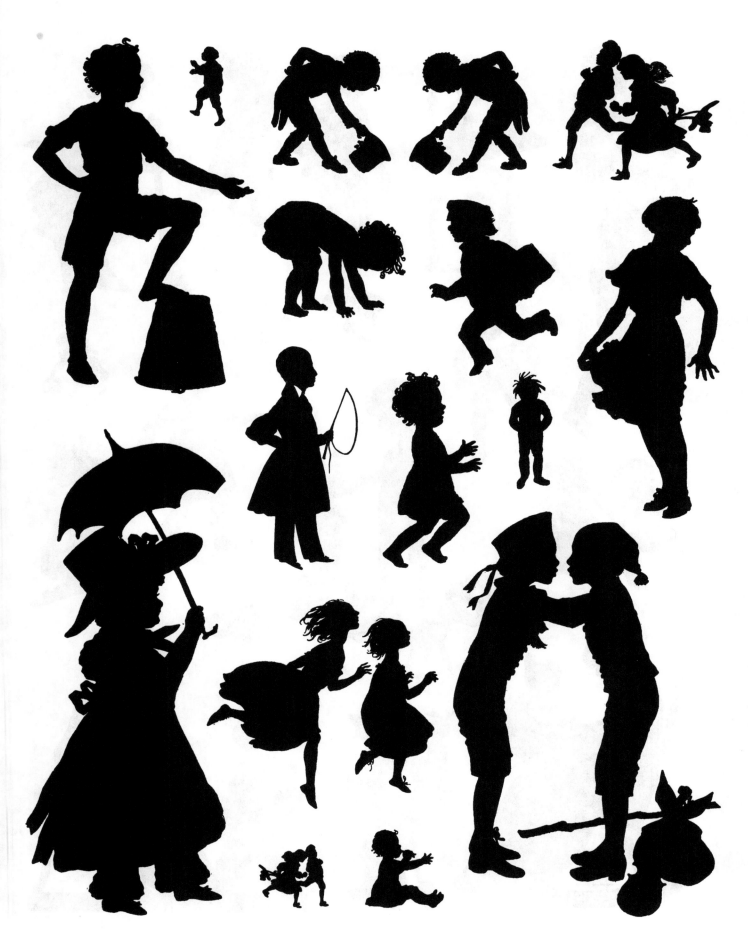

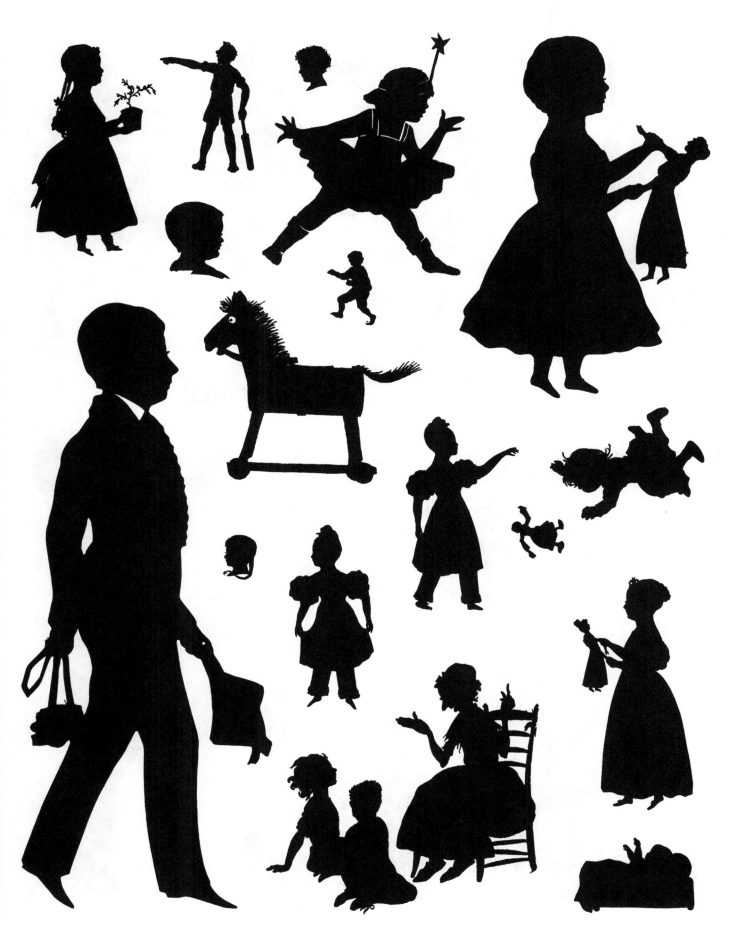

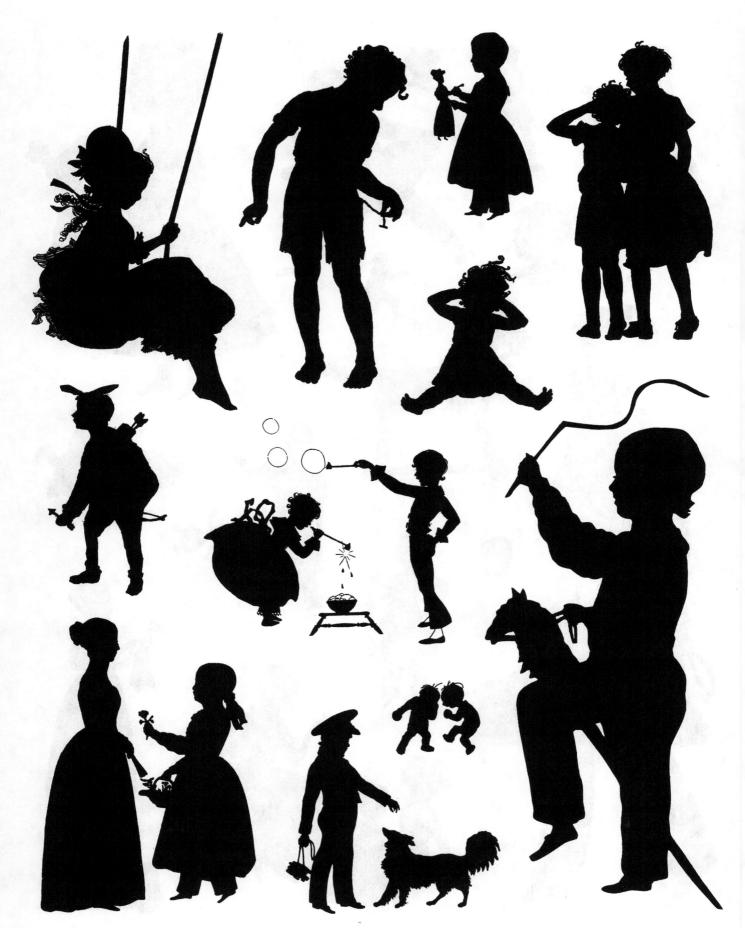

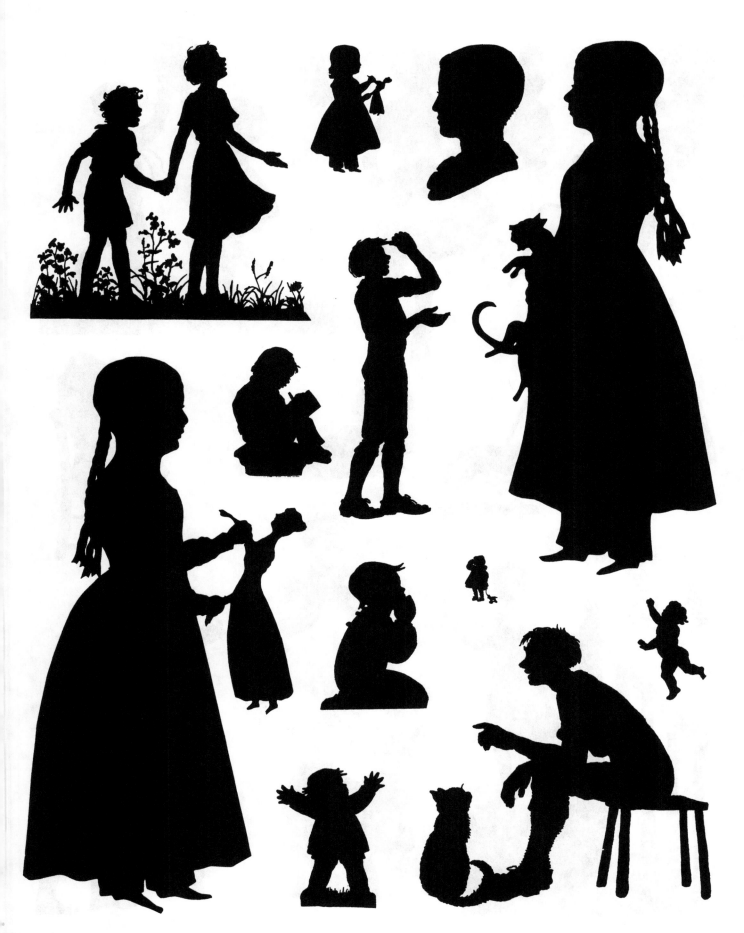

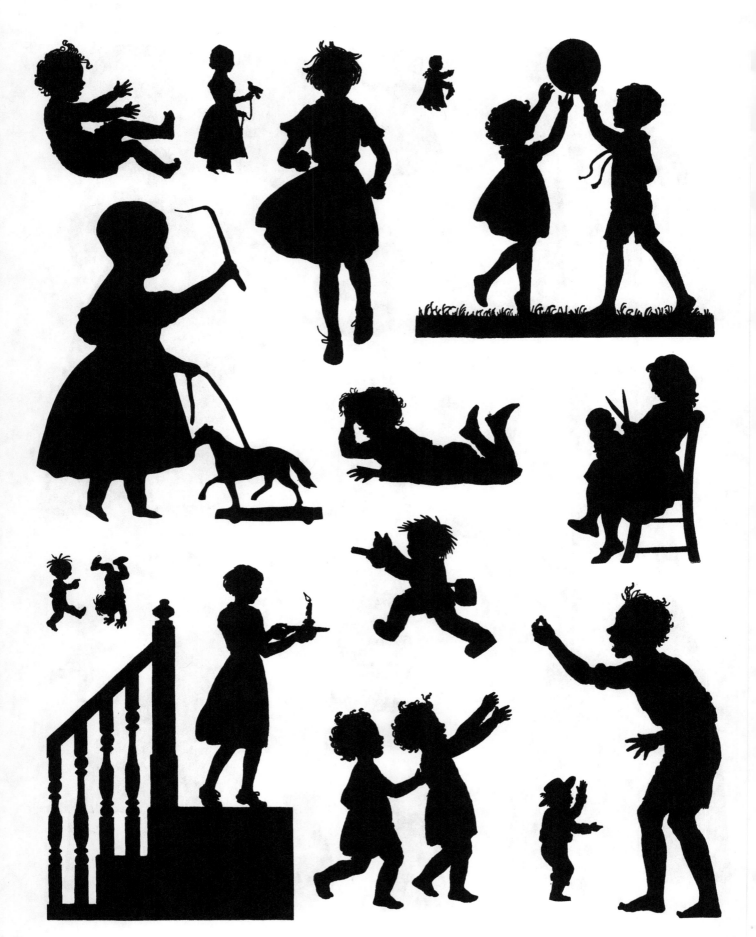

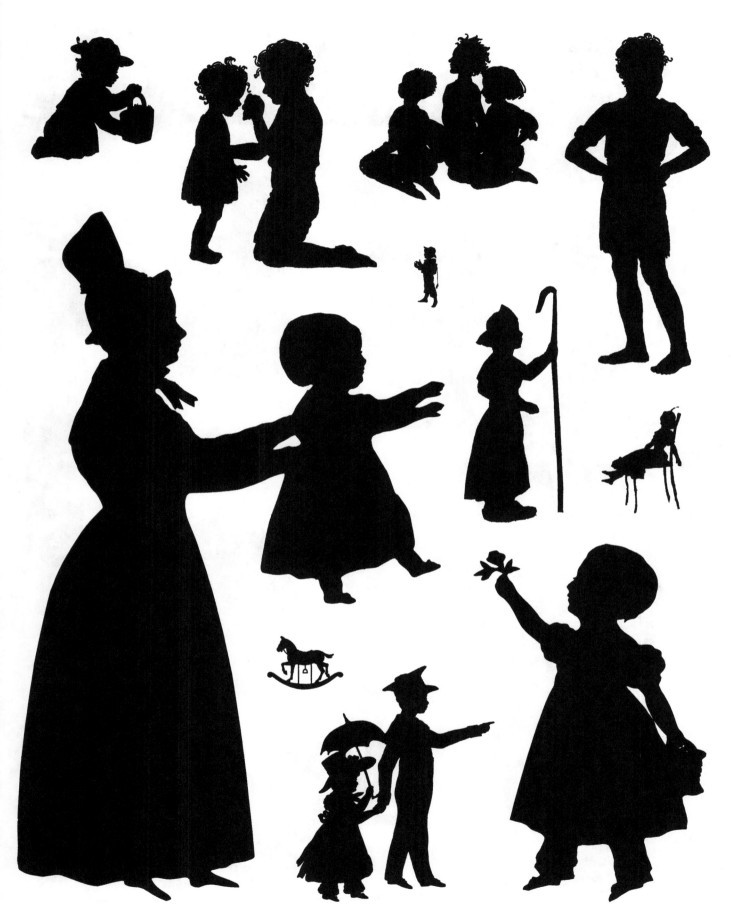

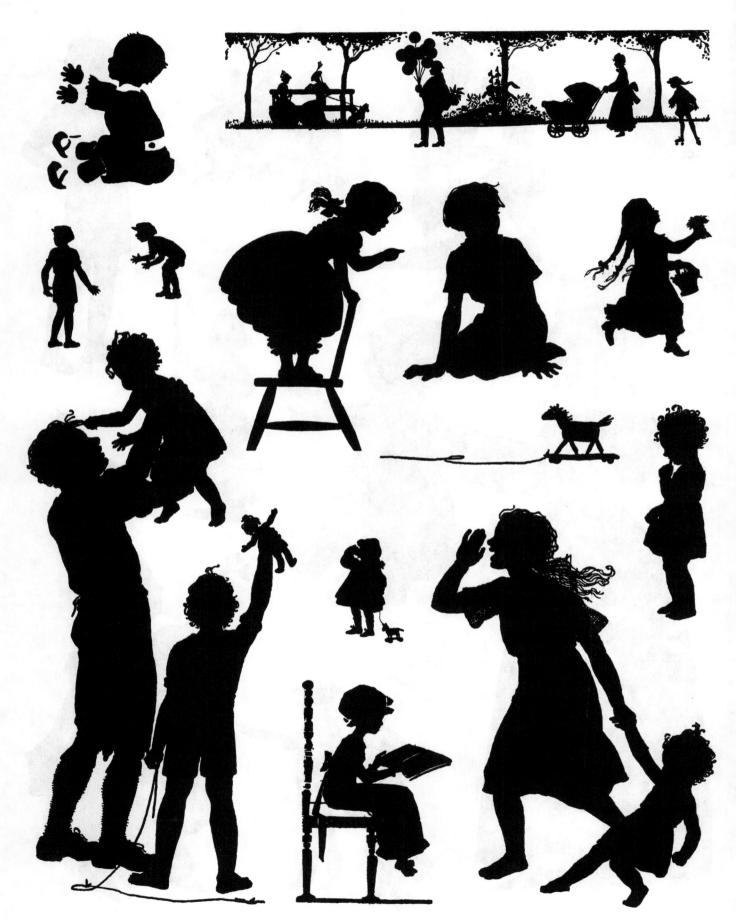

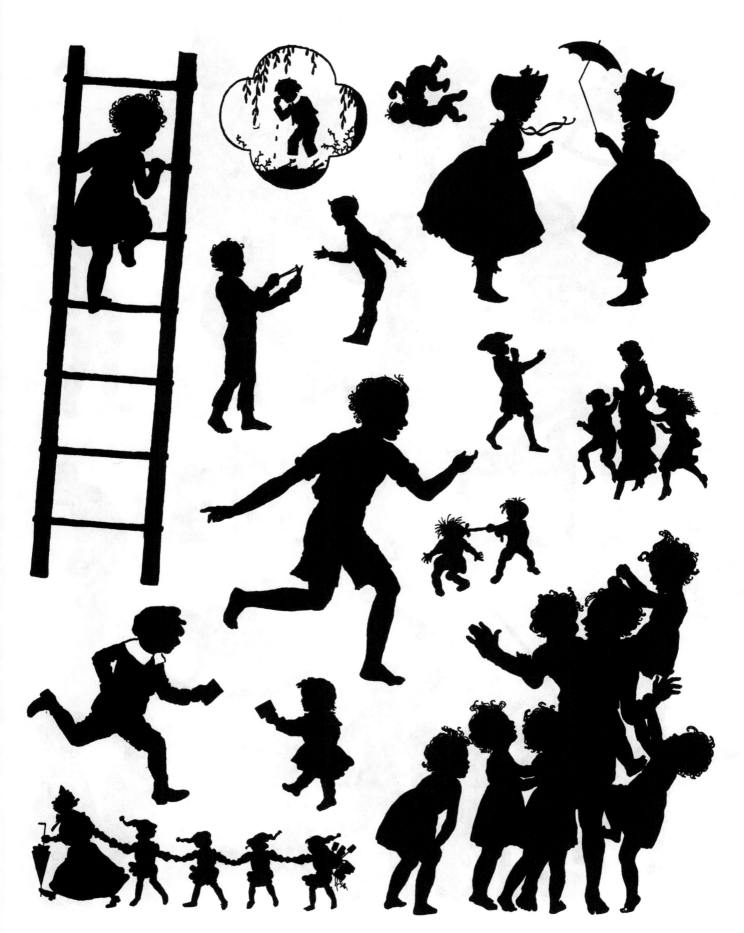

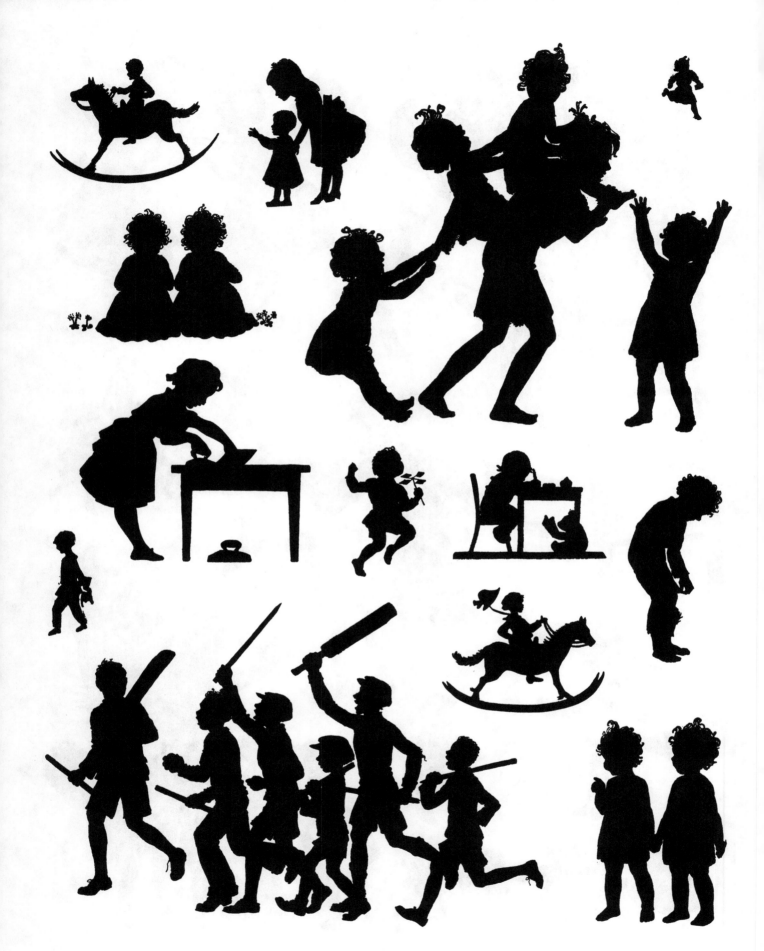

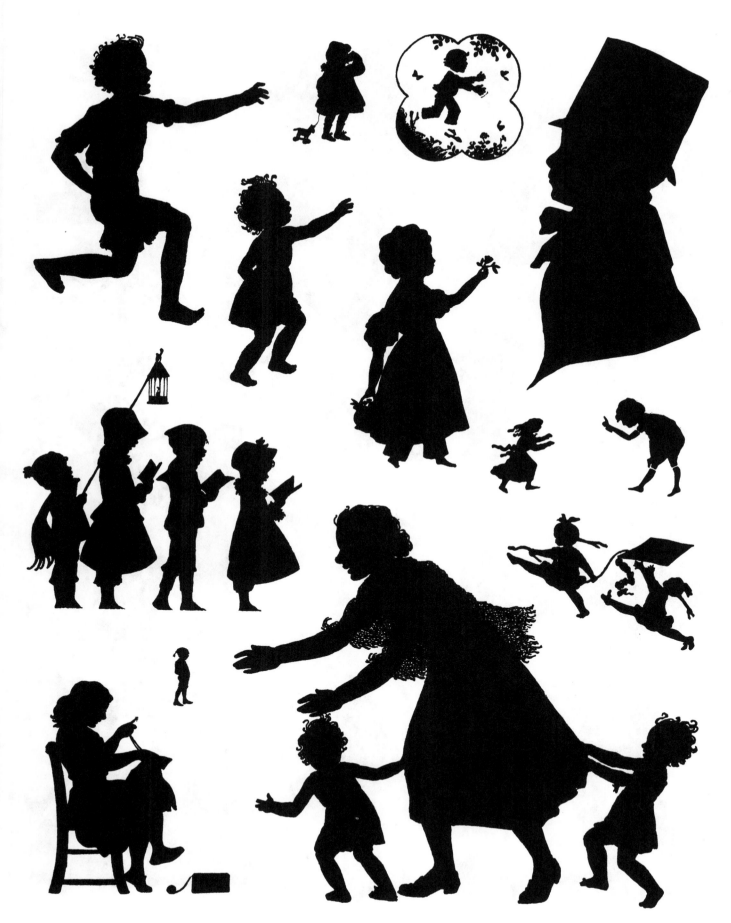

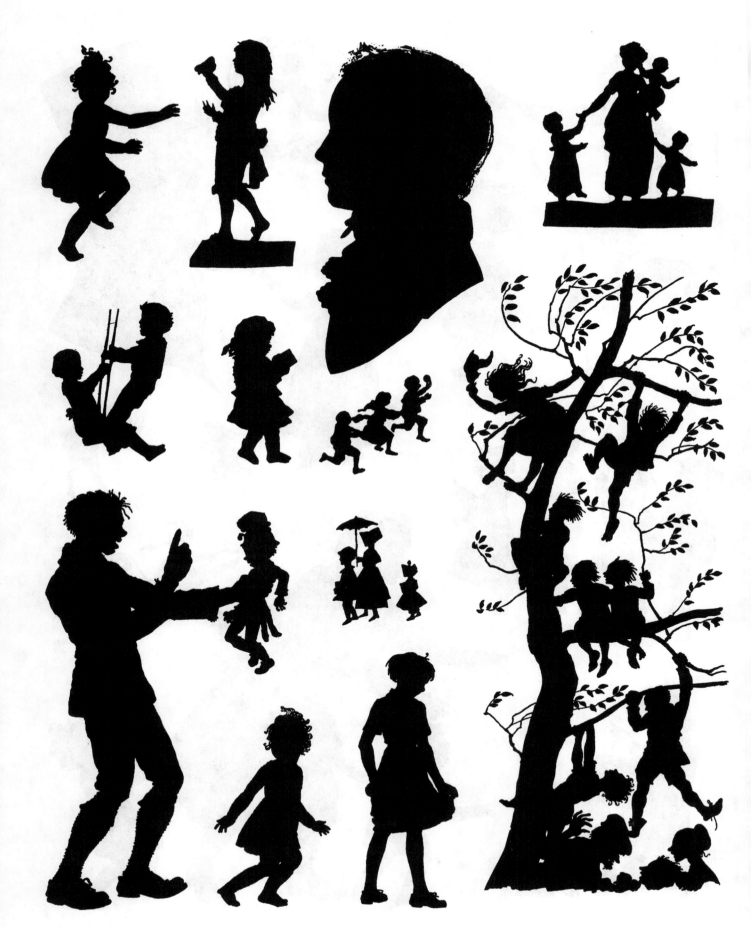

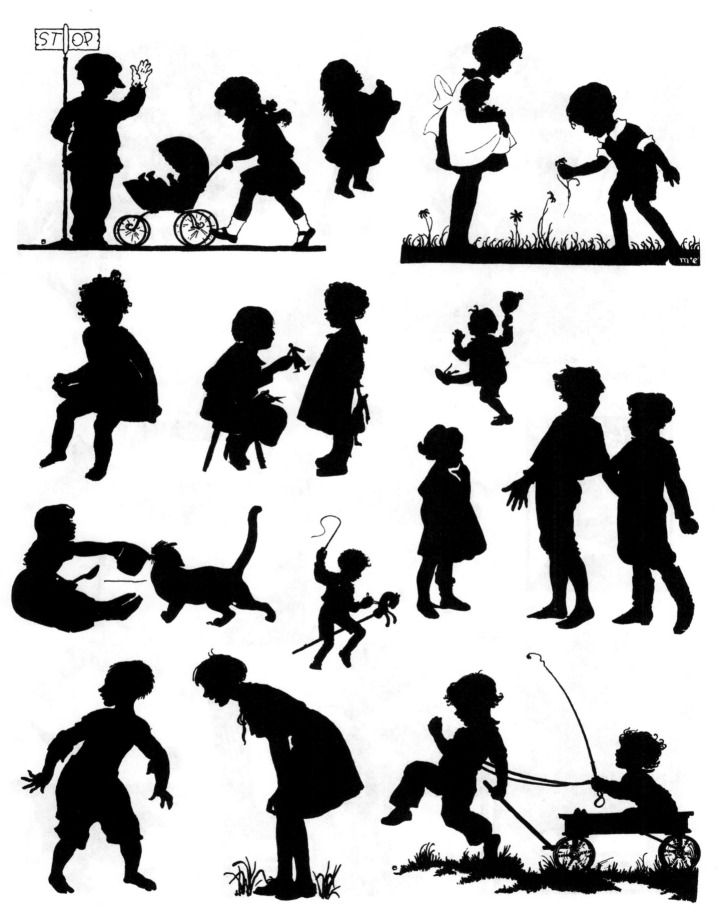

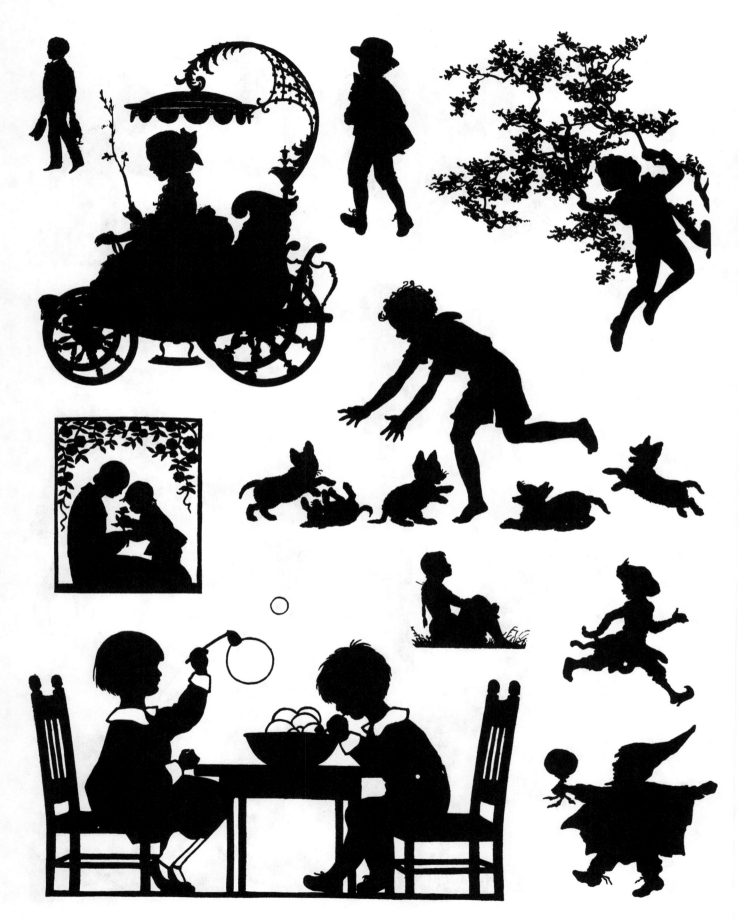

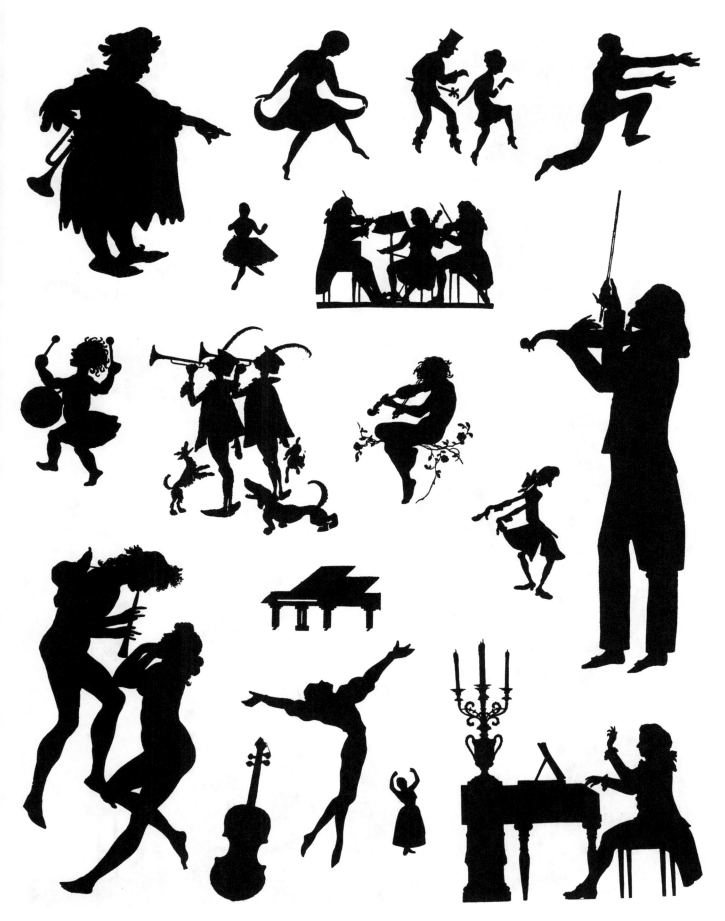

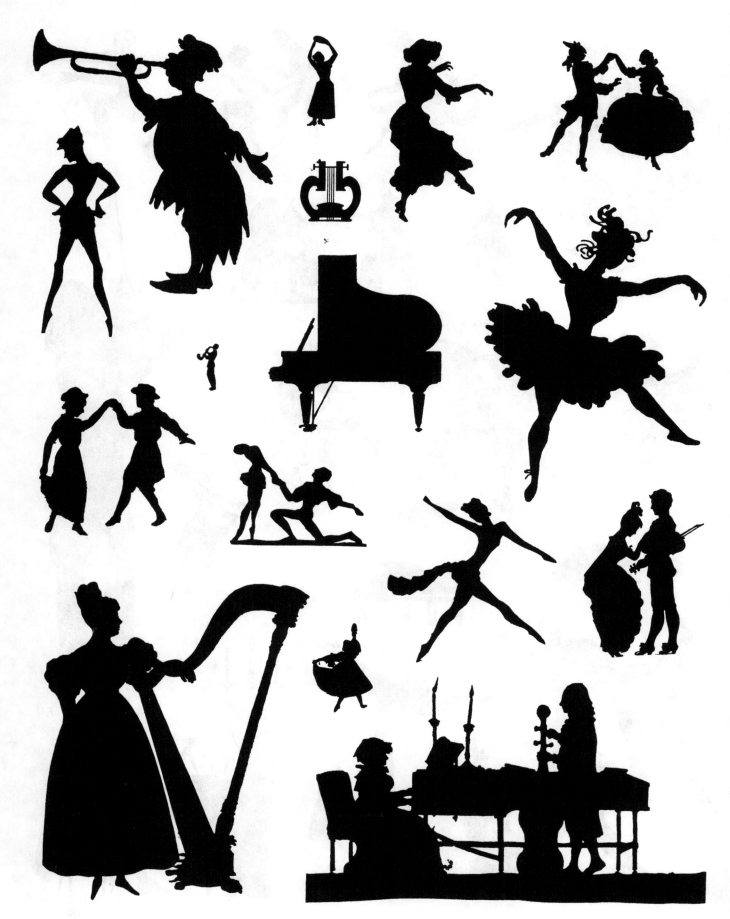

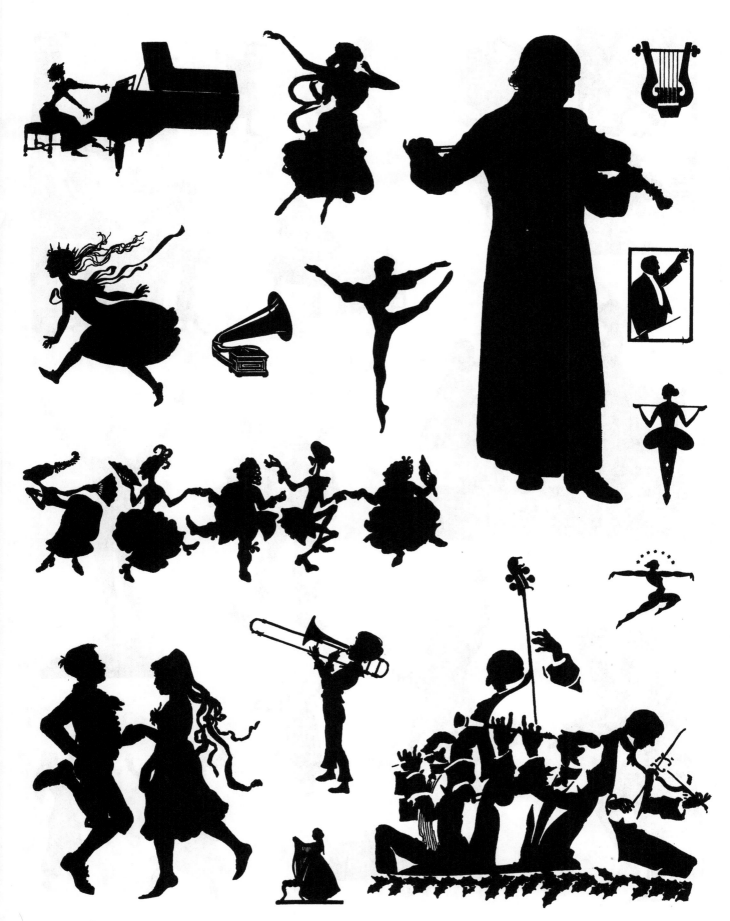

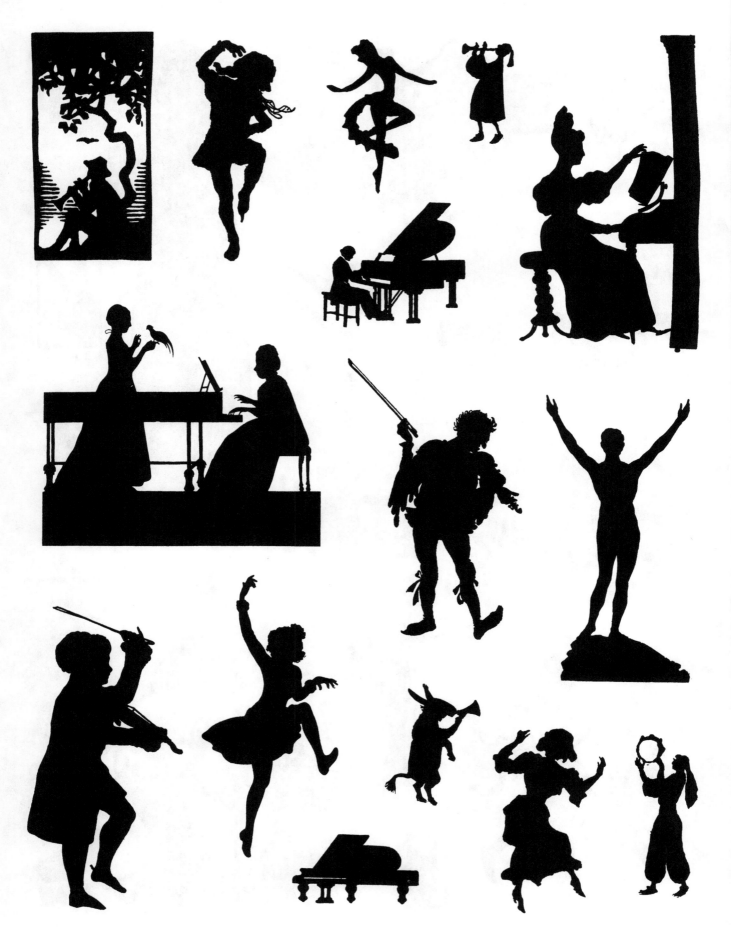

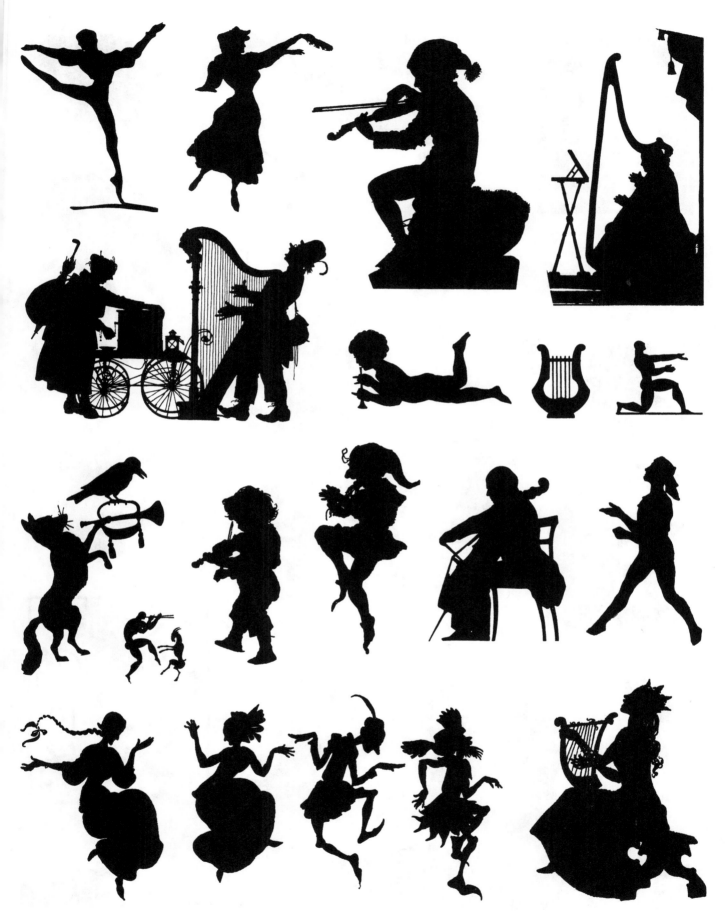

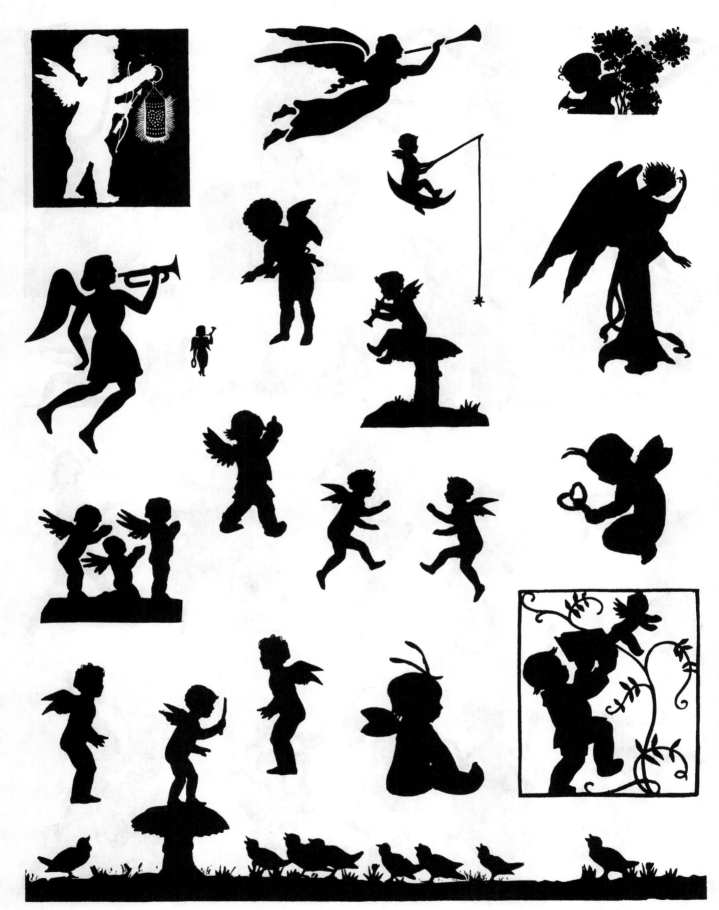

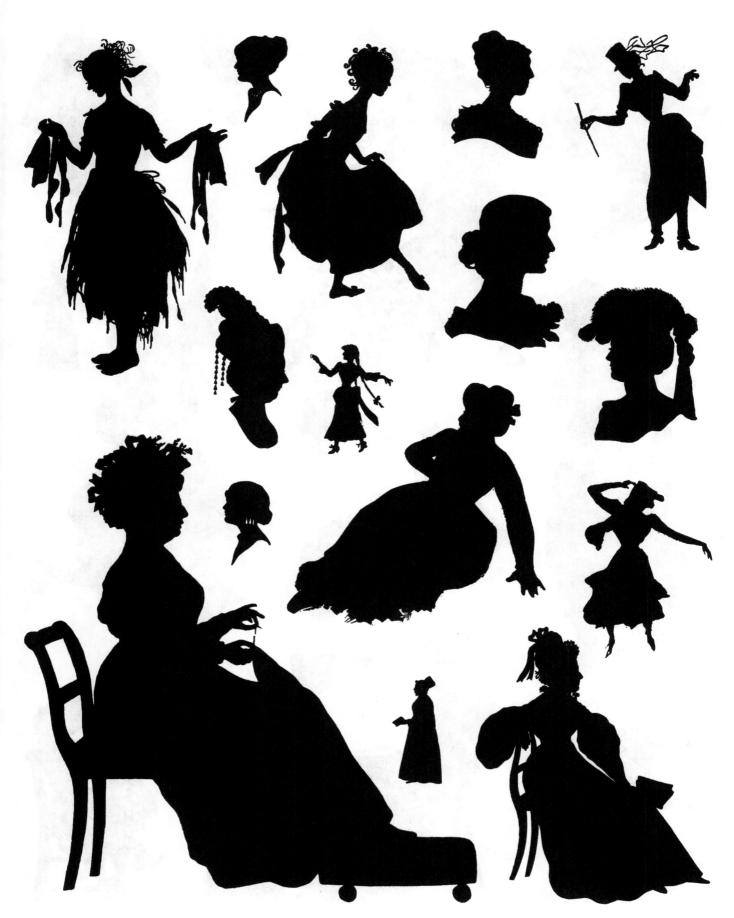

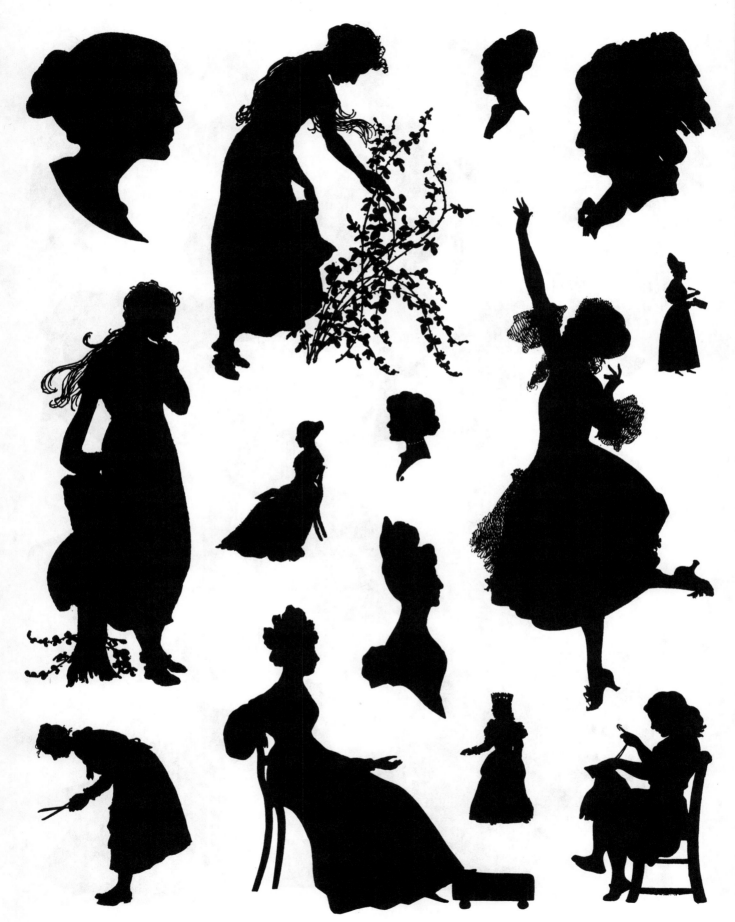

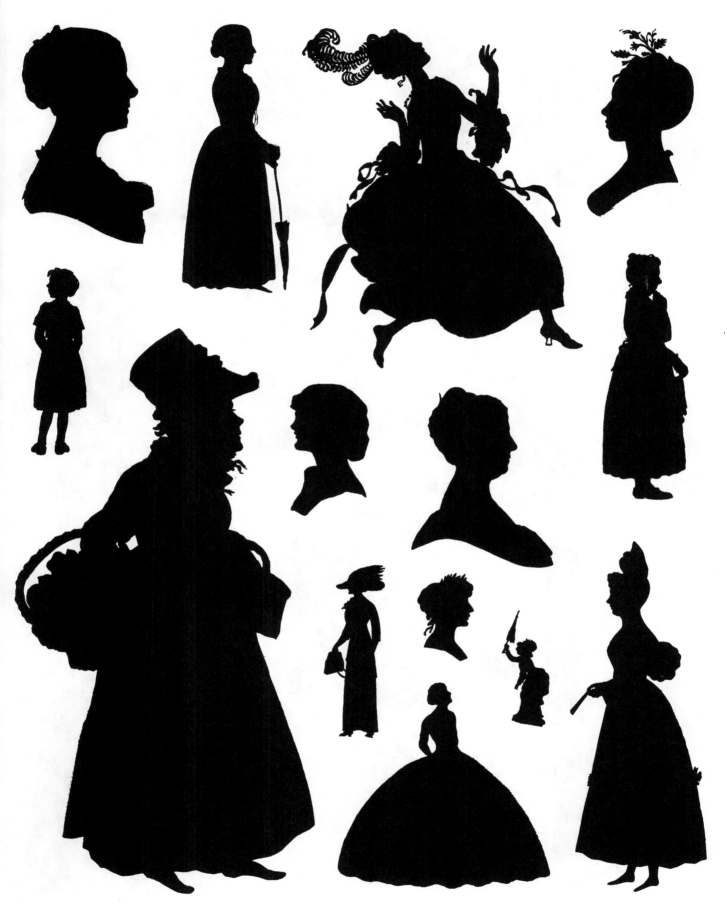

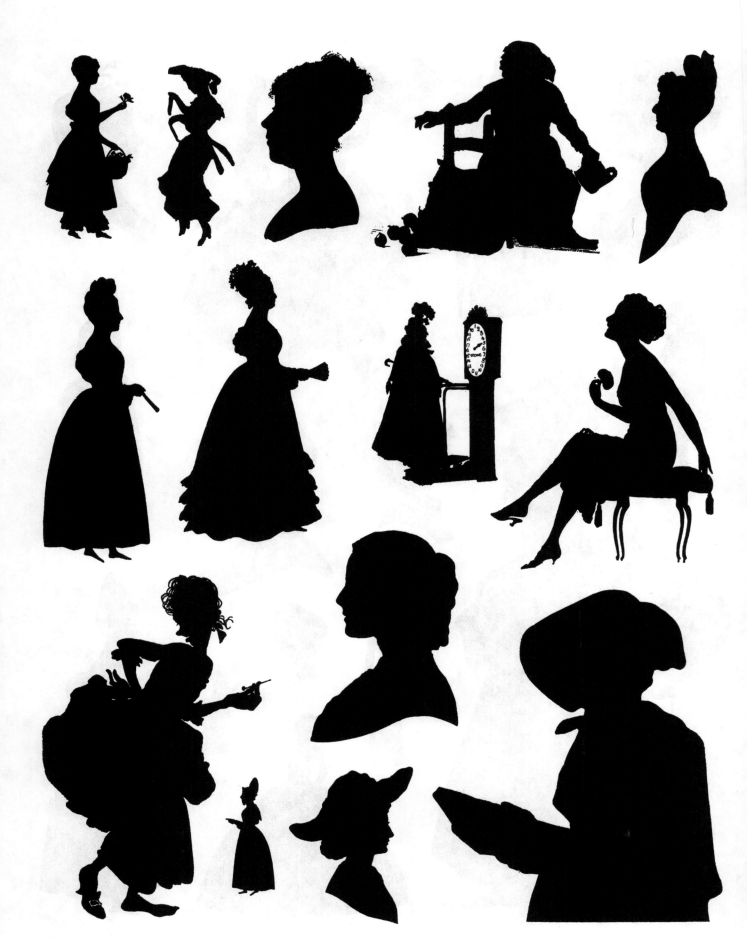

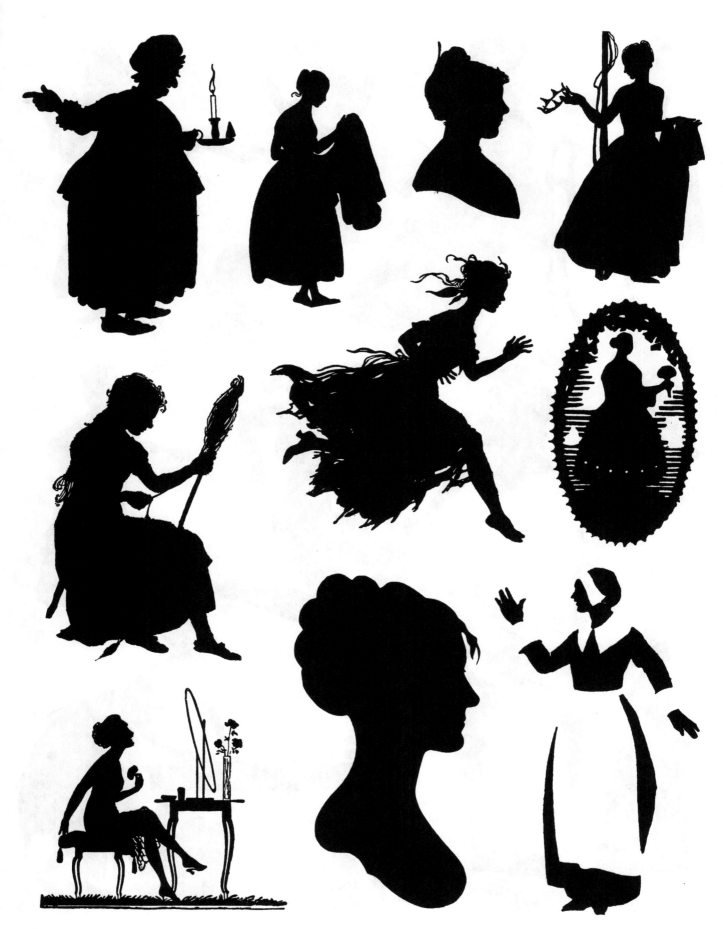

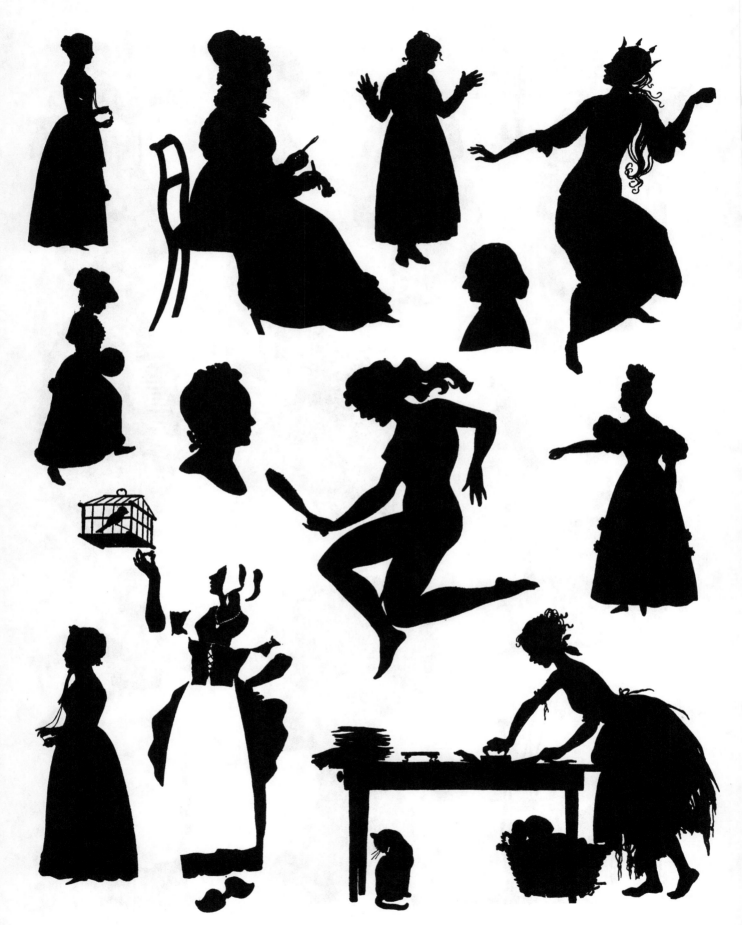

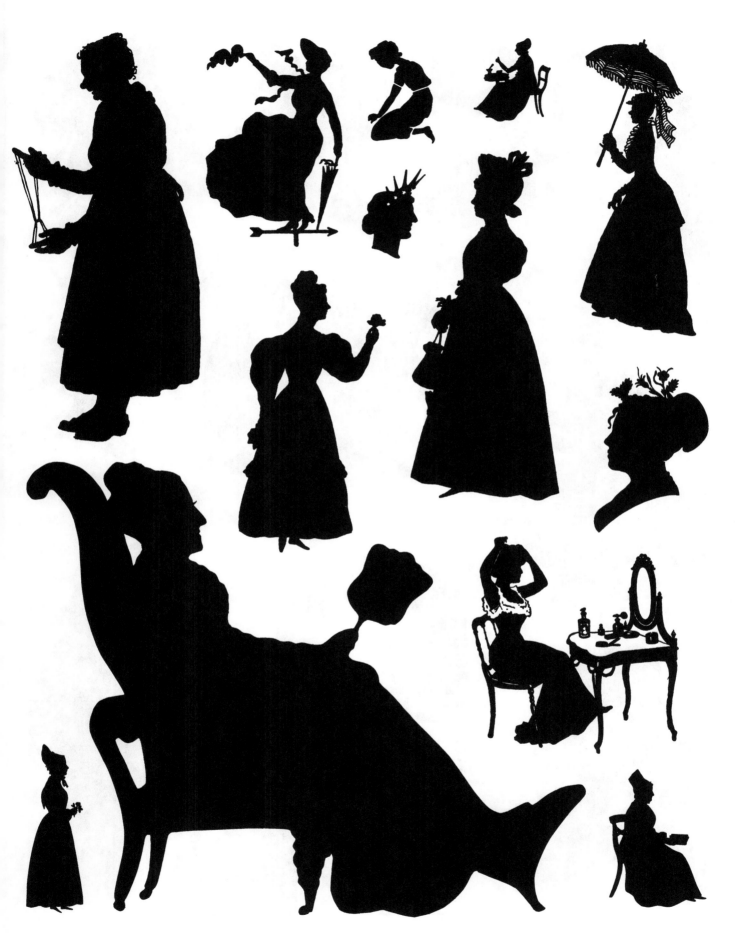

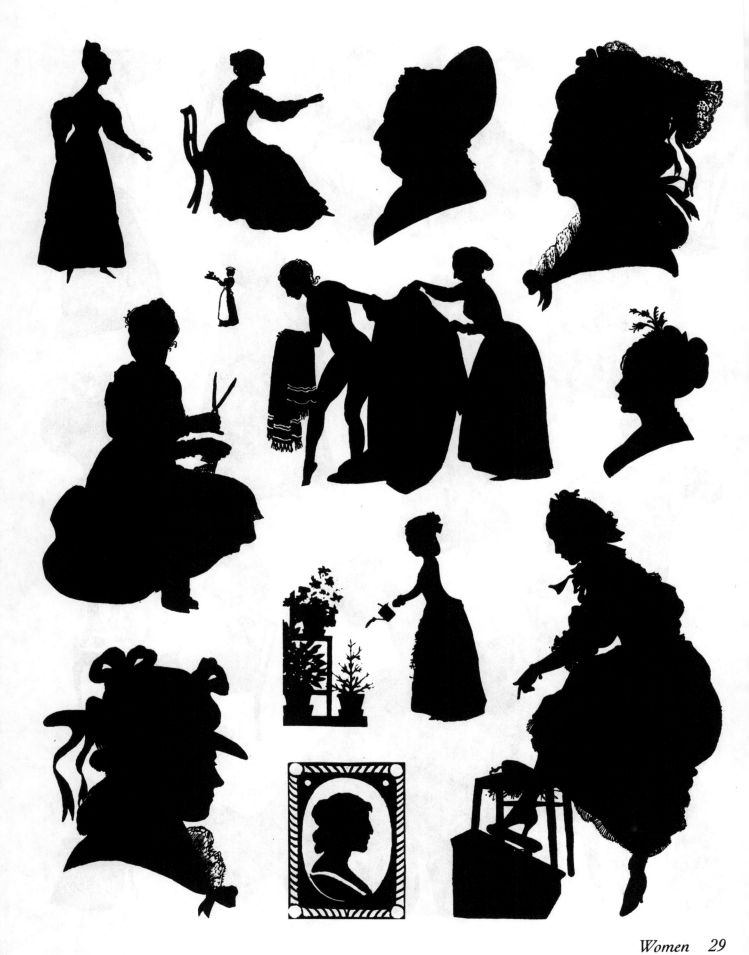

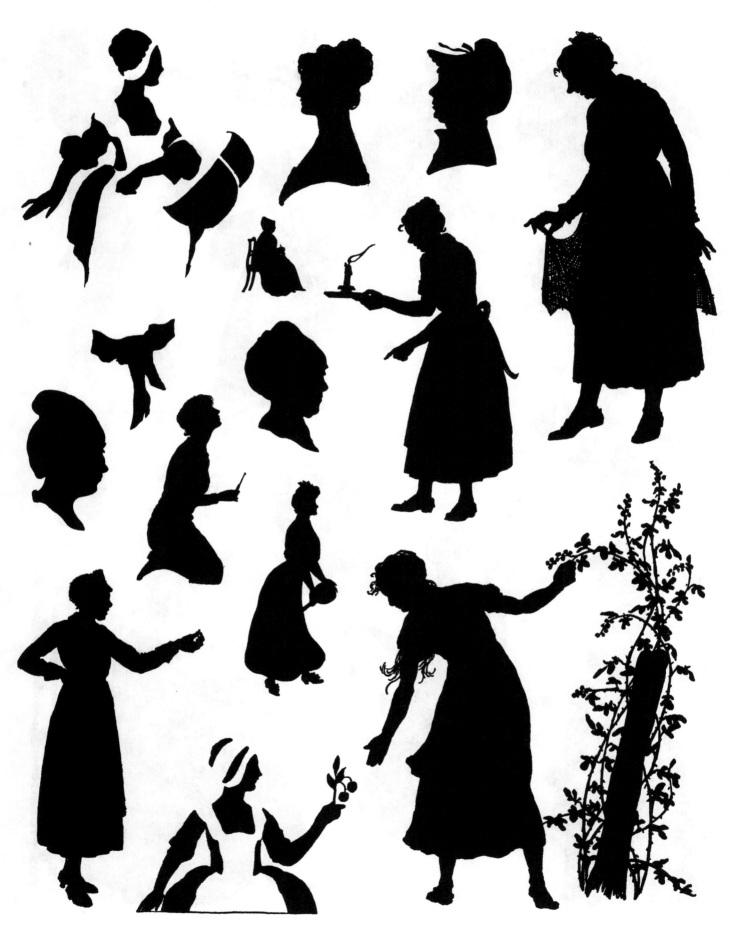

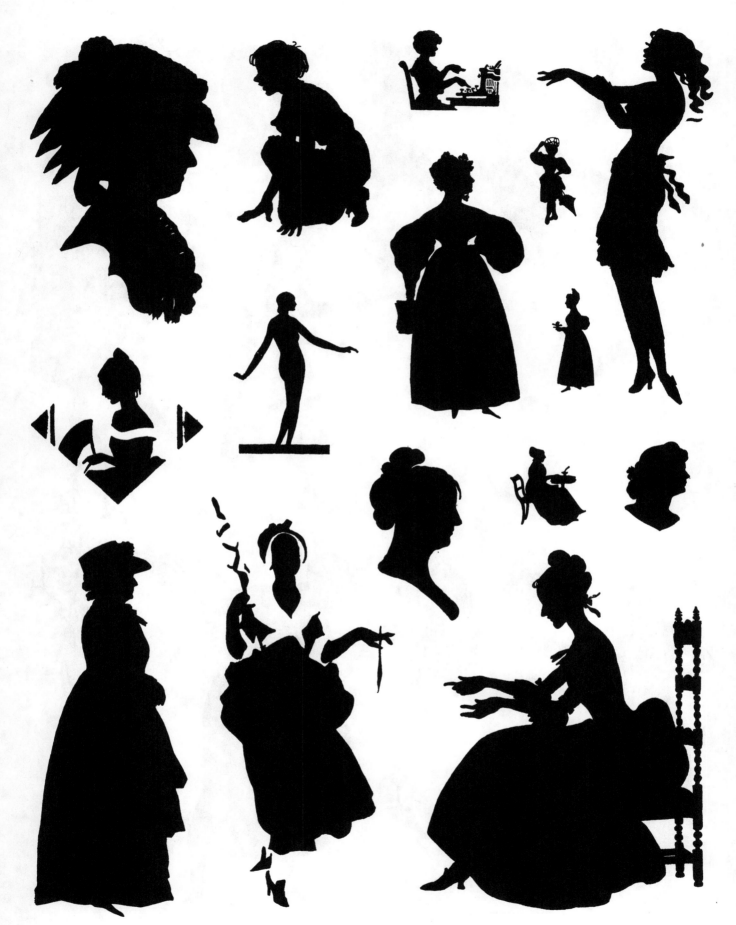

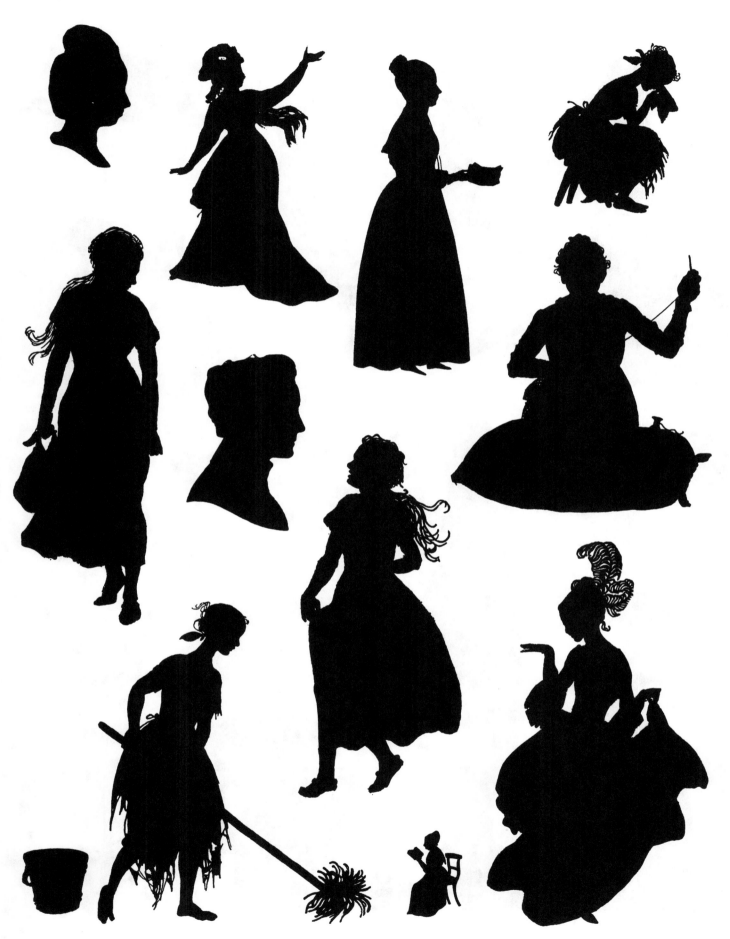

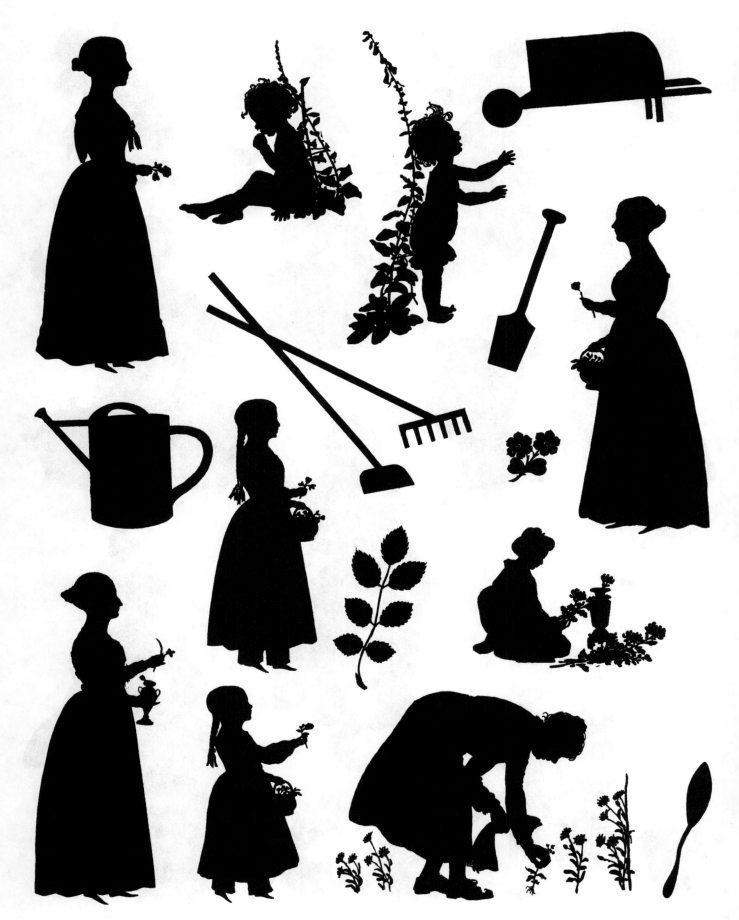

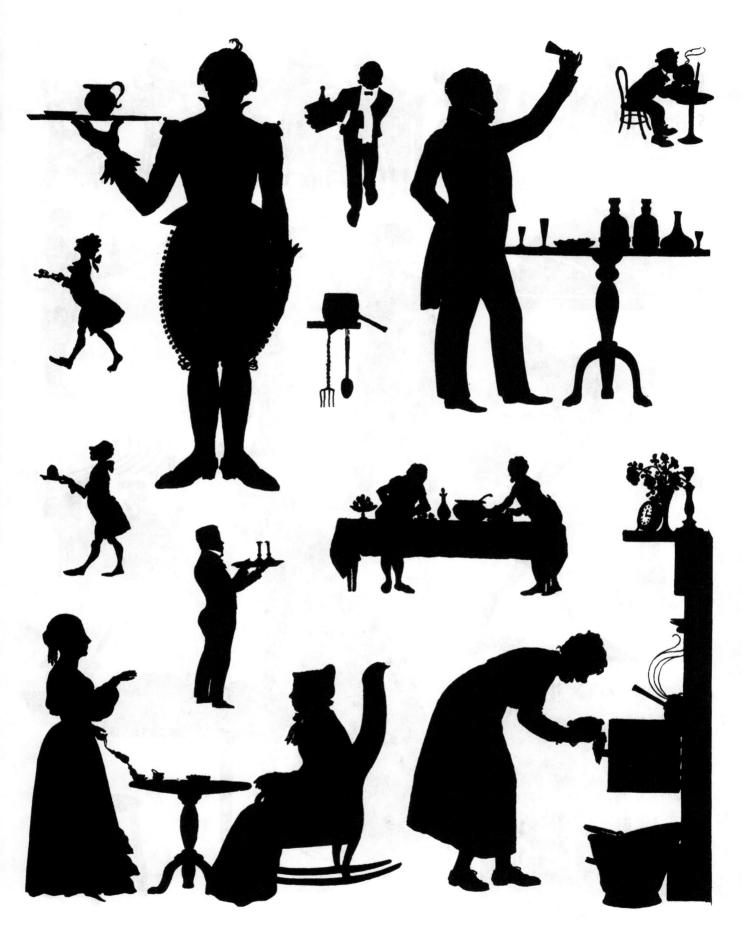

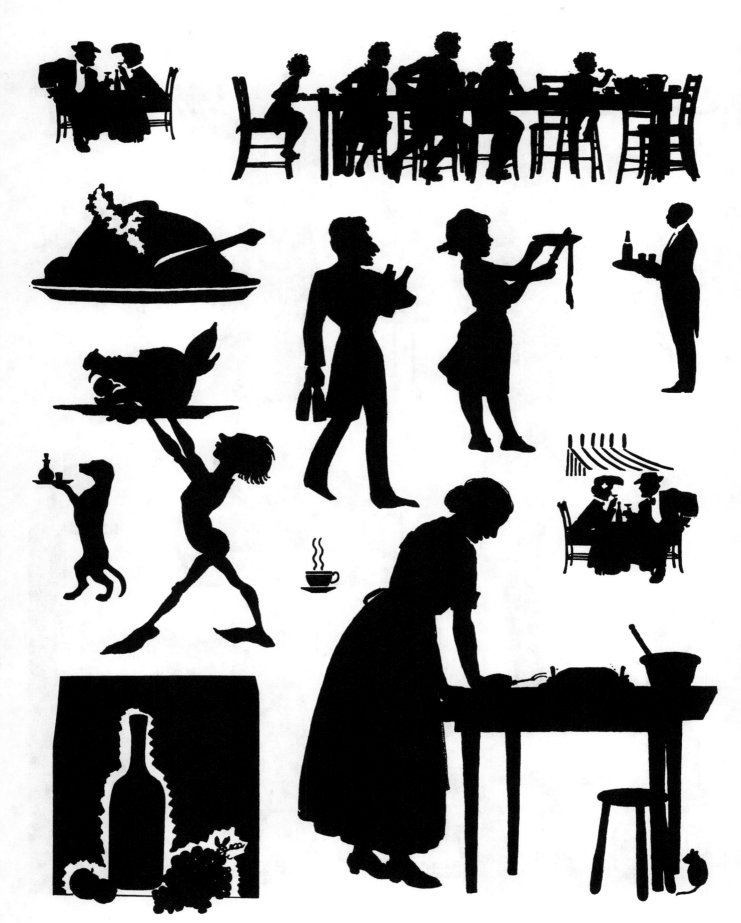

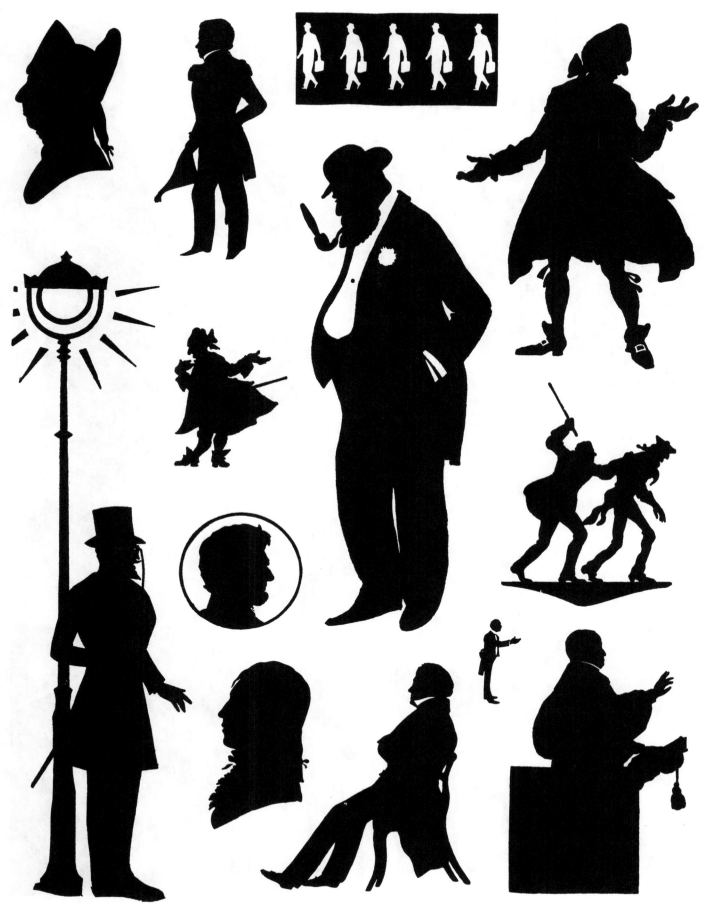

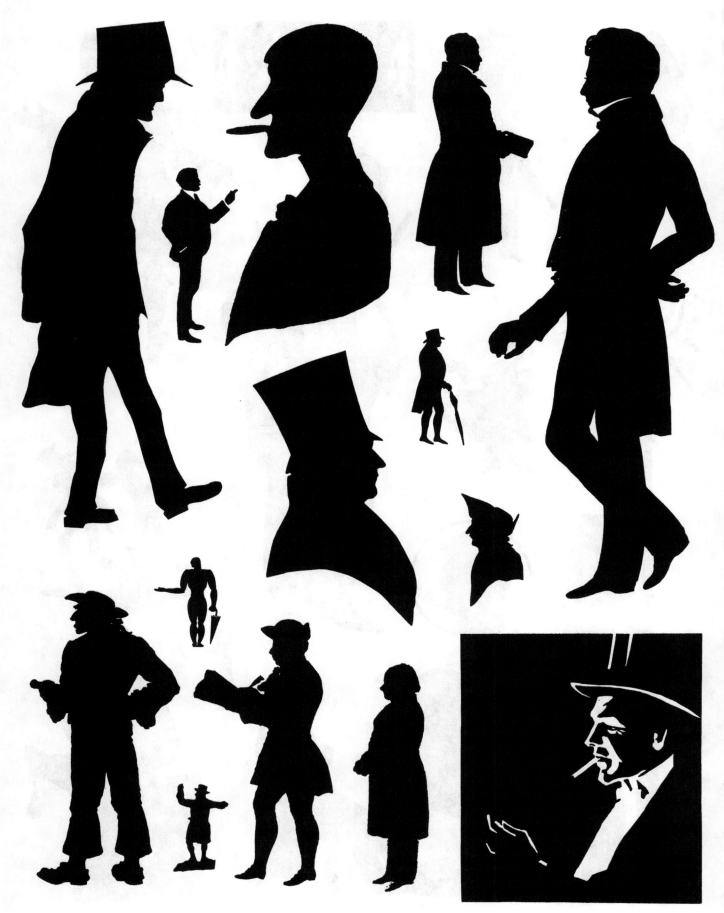

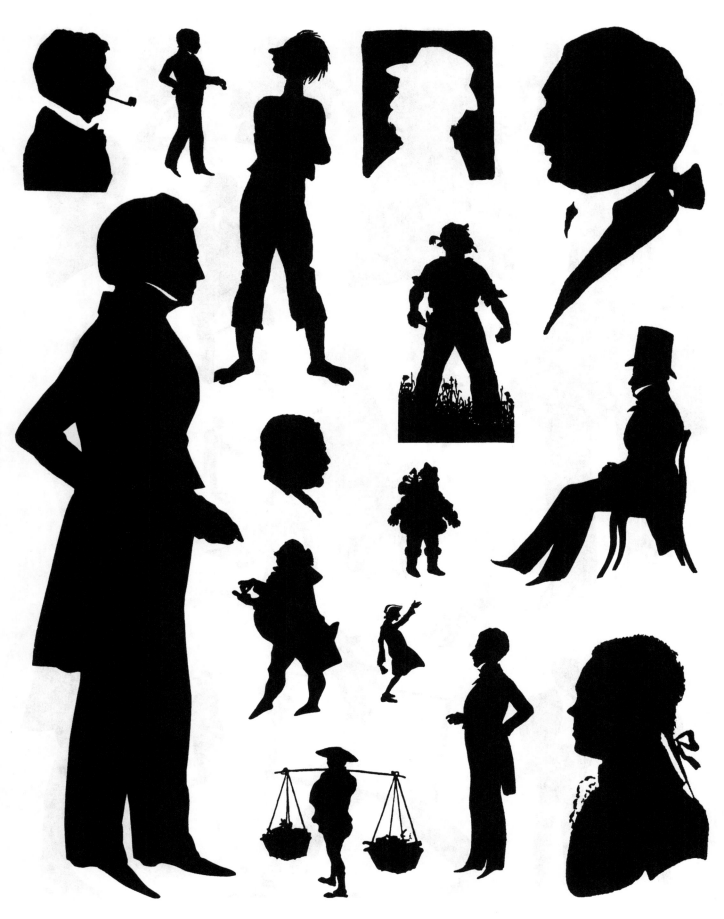

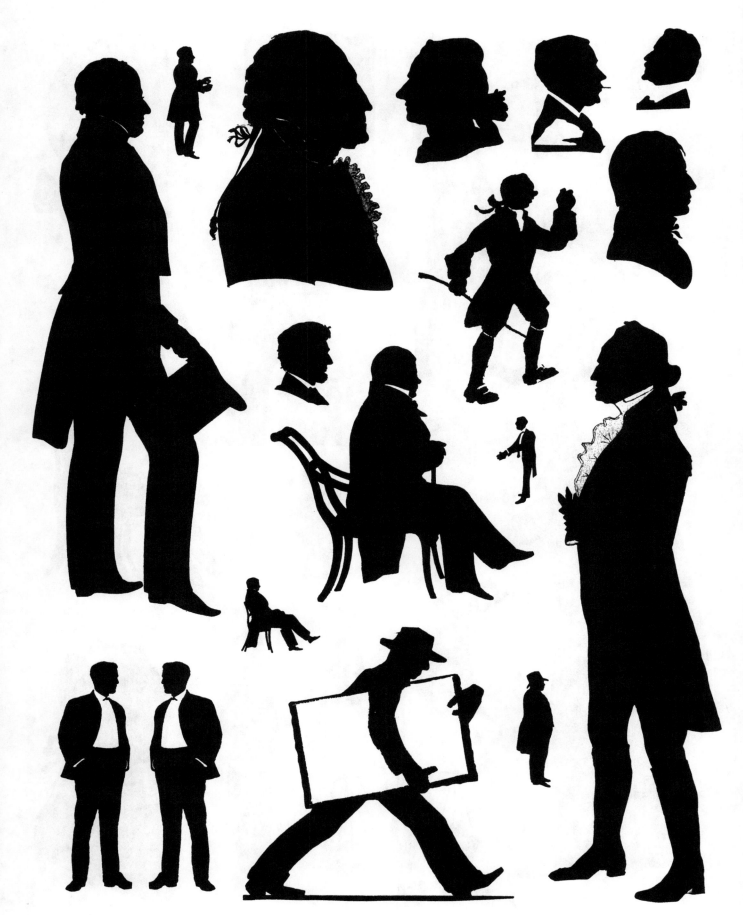

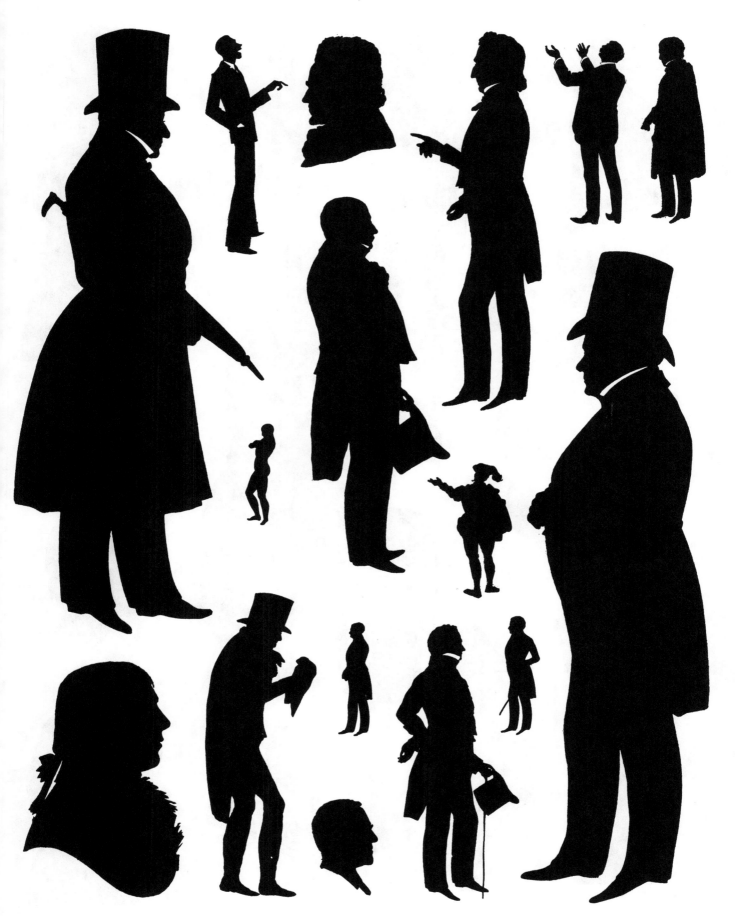

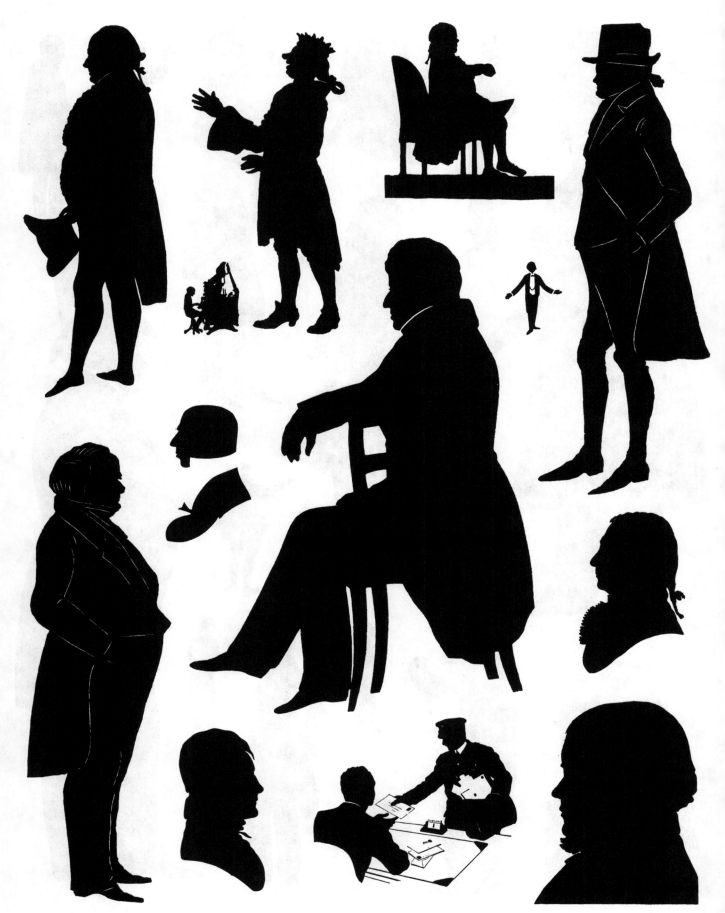

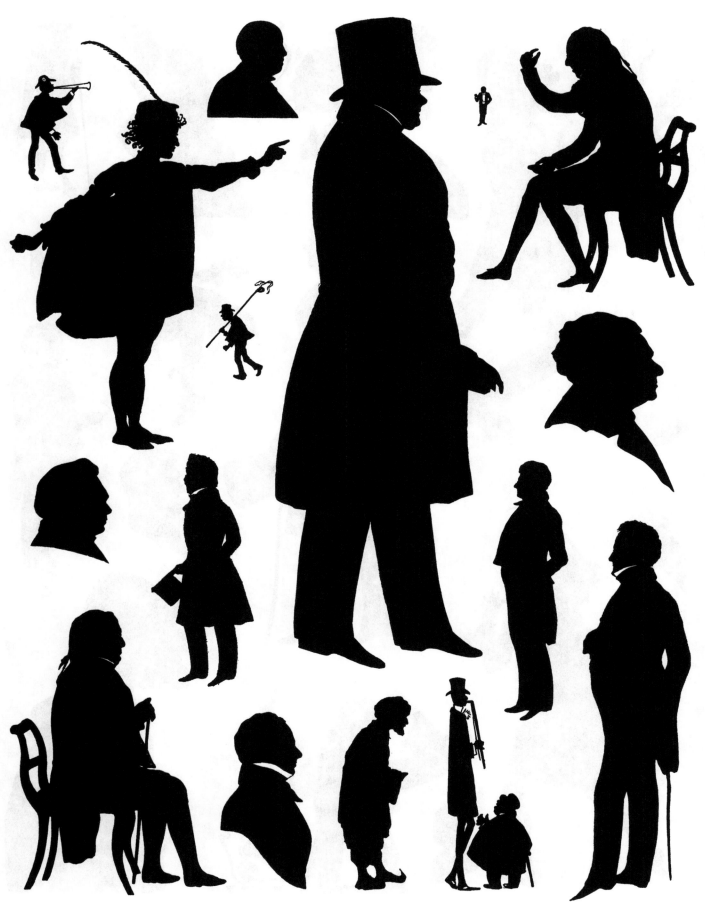

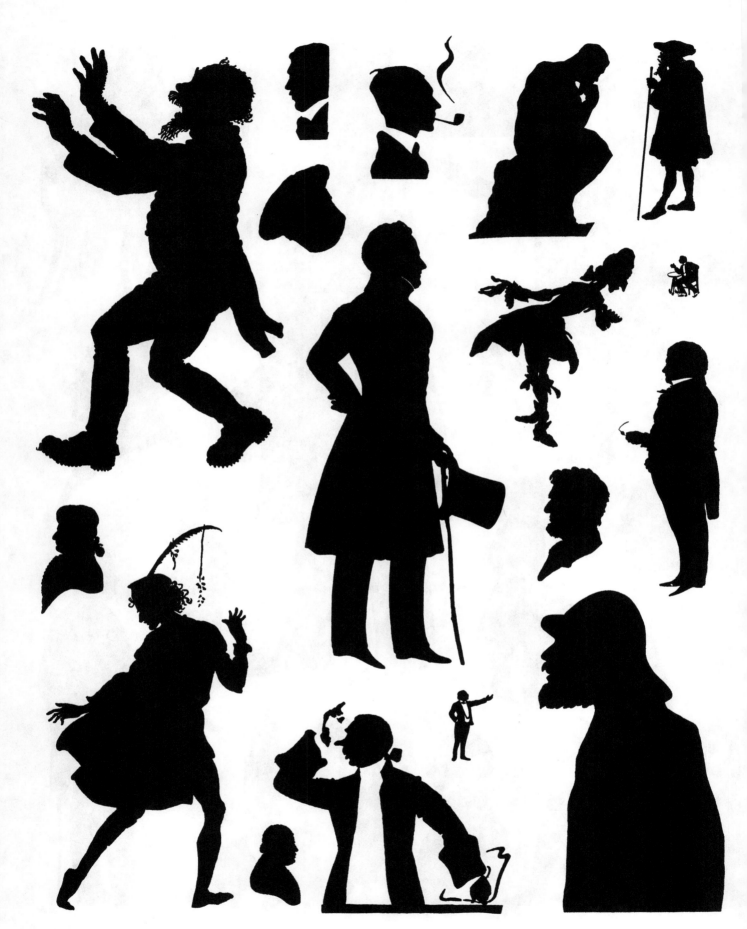

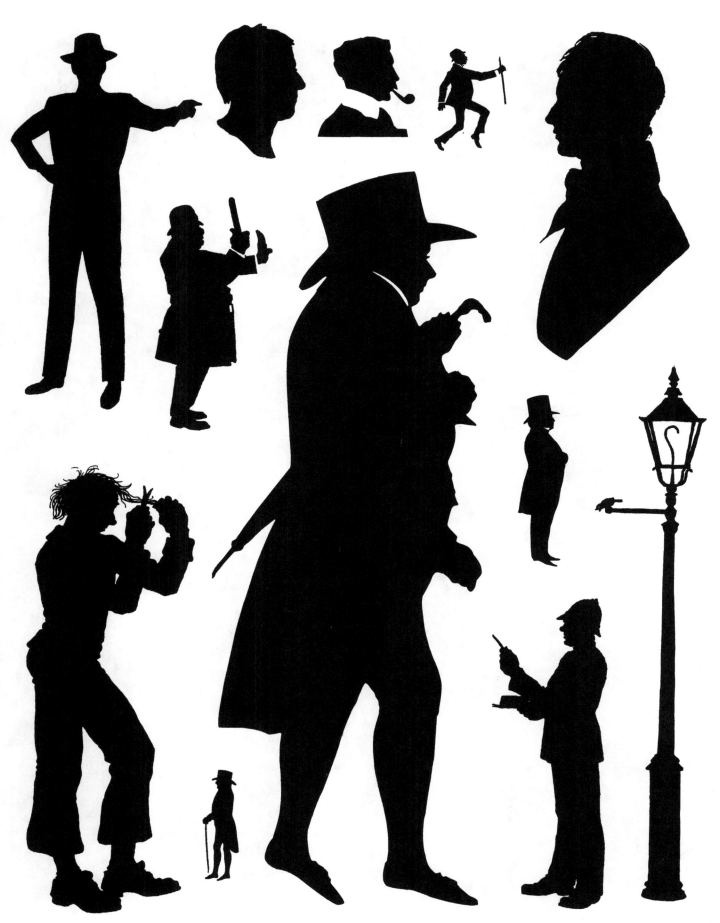

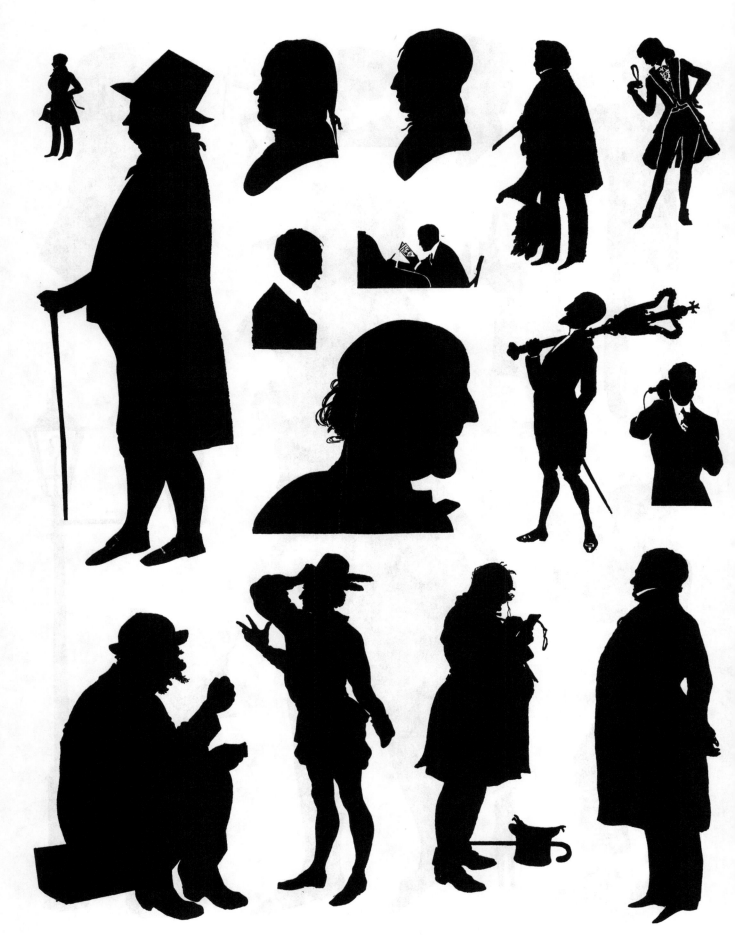

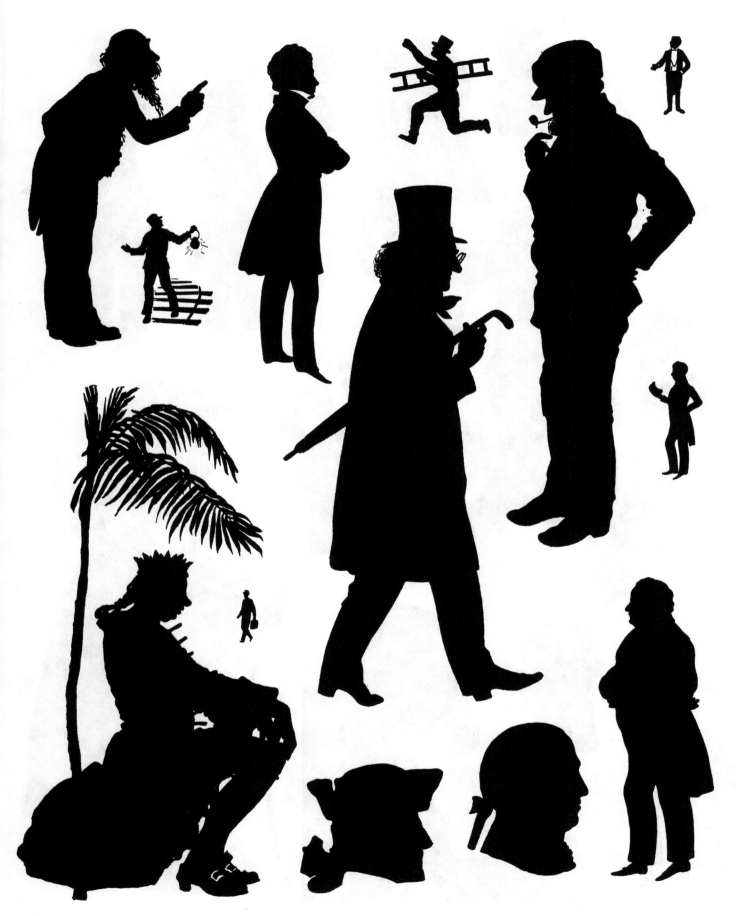

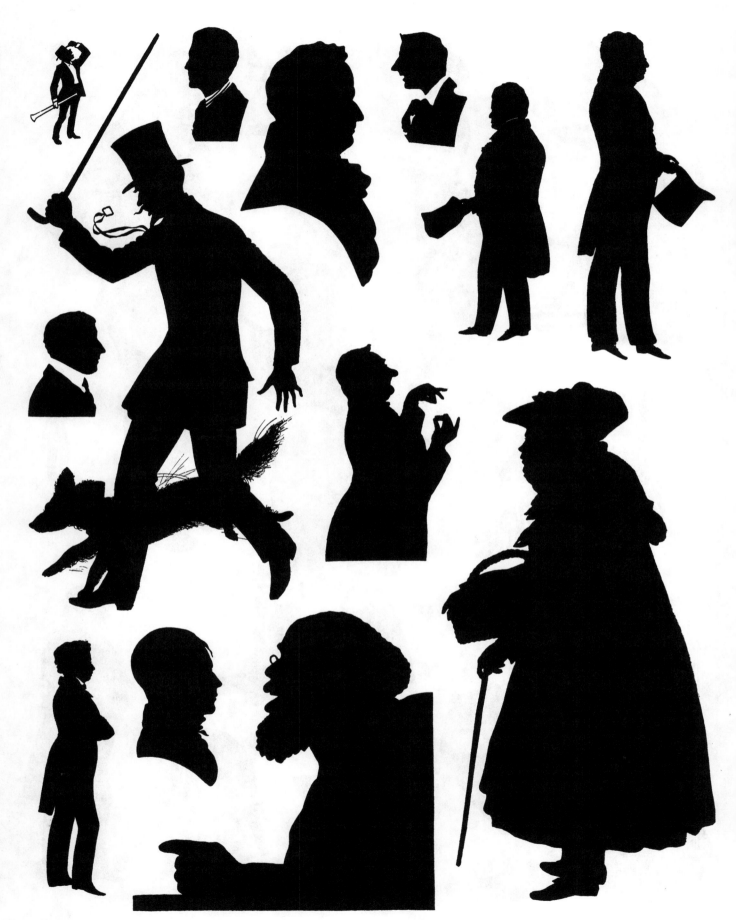

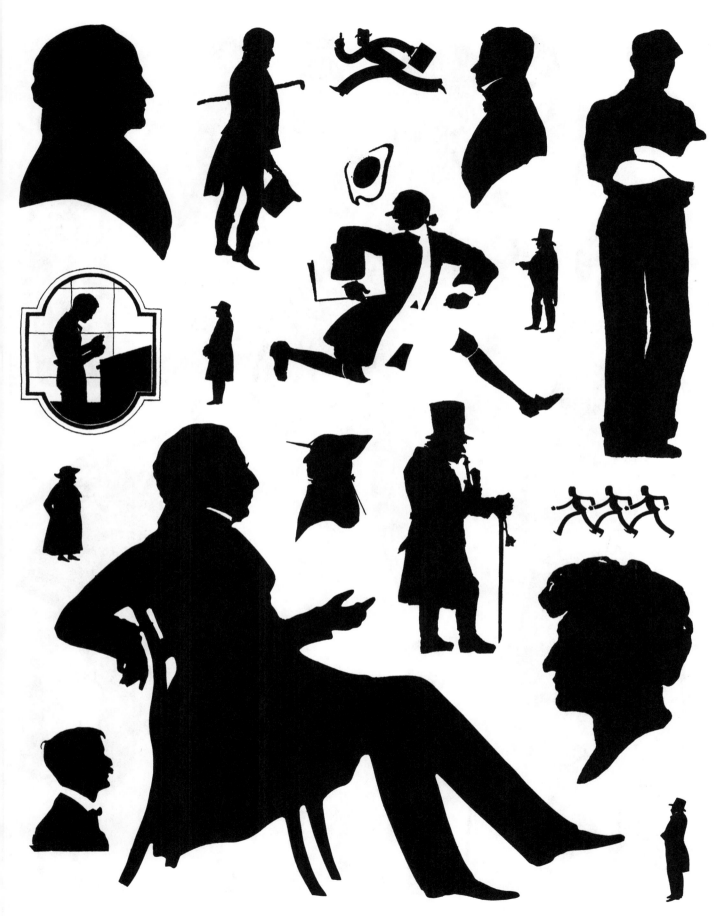

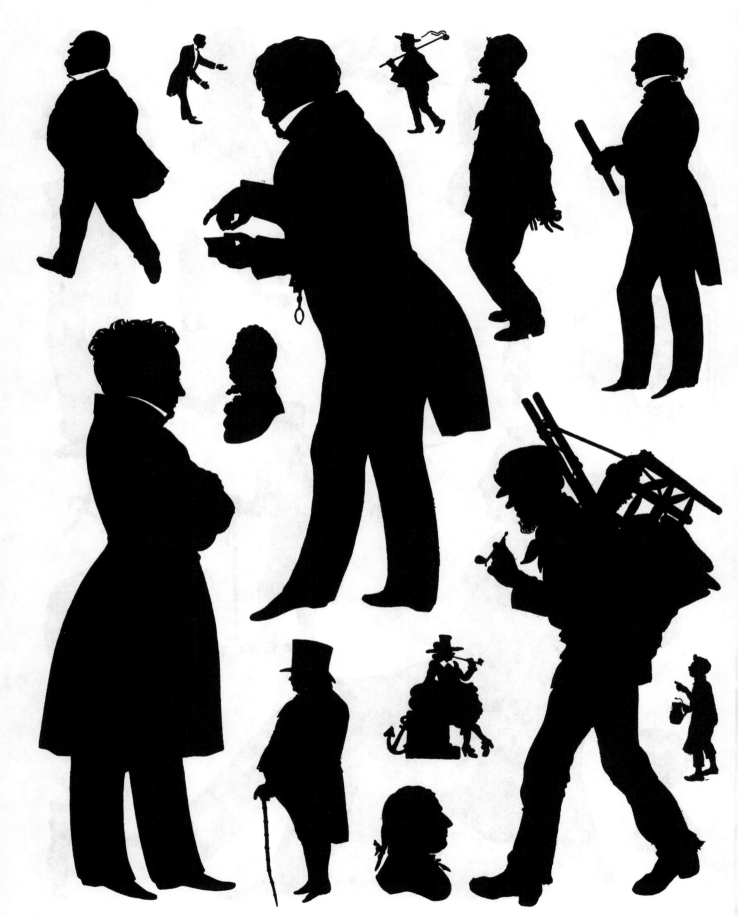

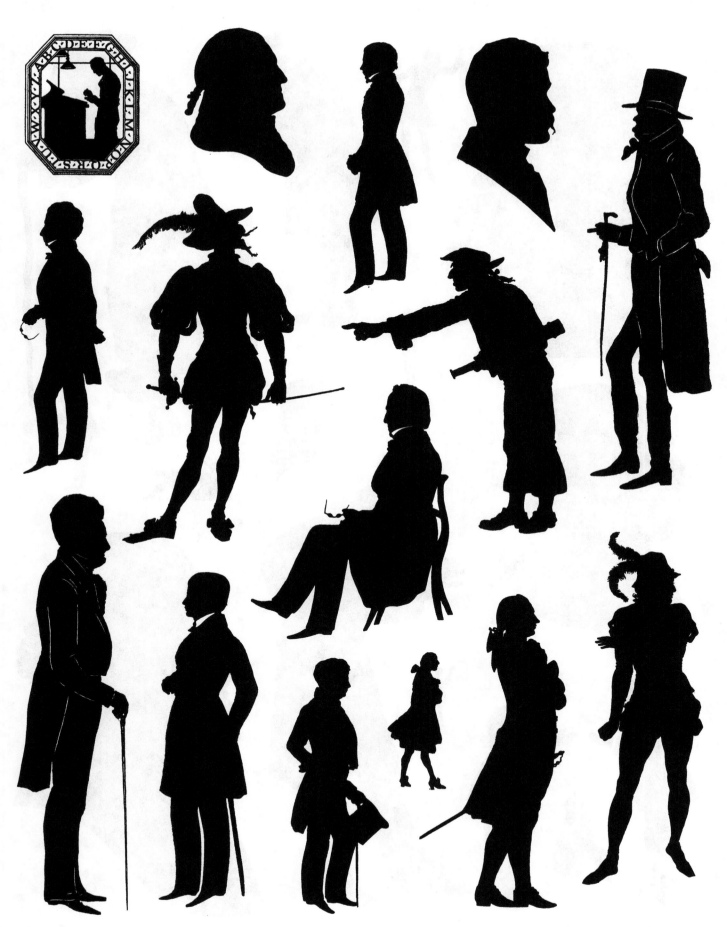

58 Men

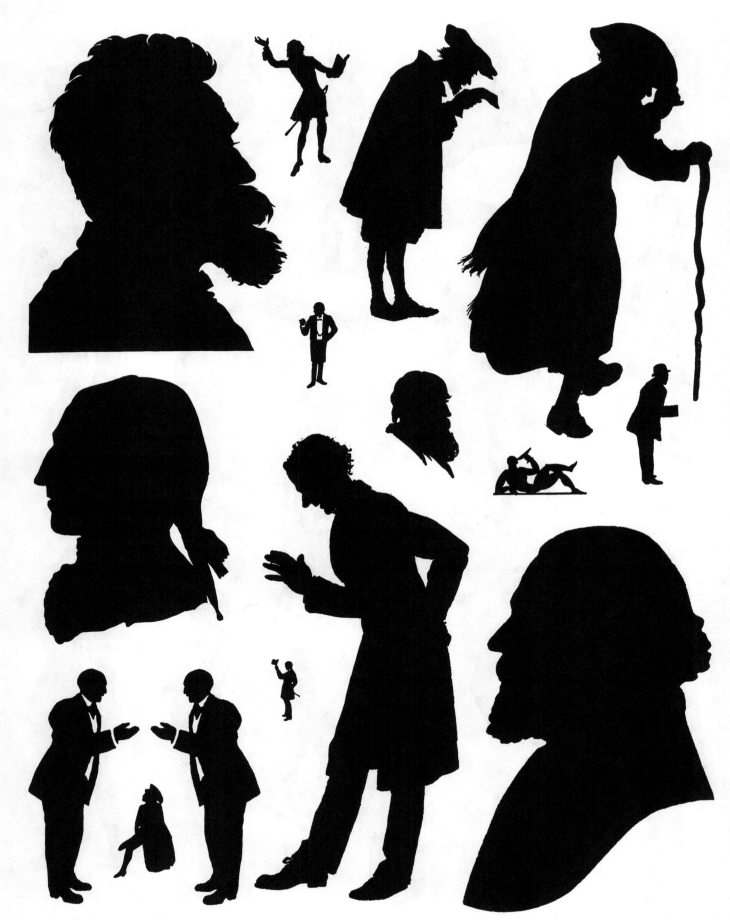

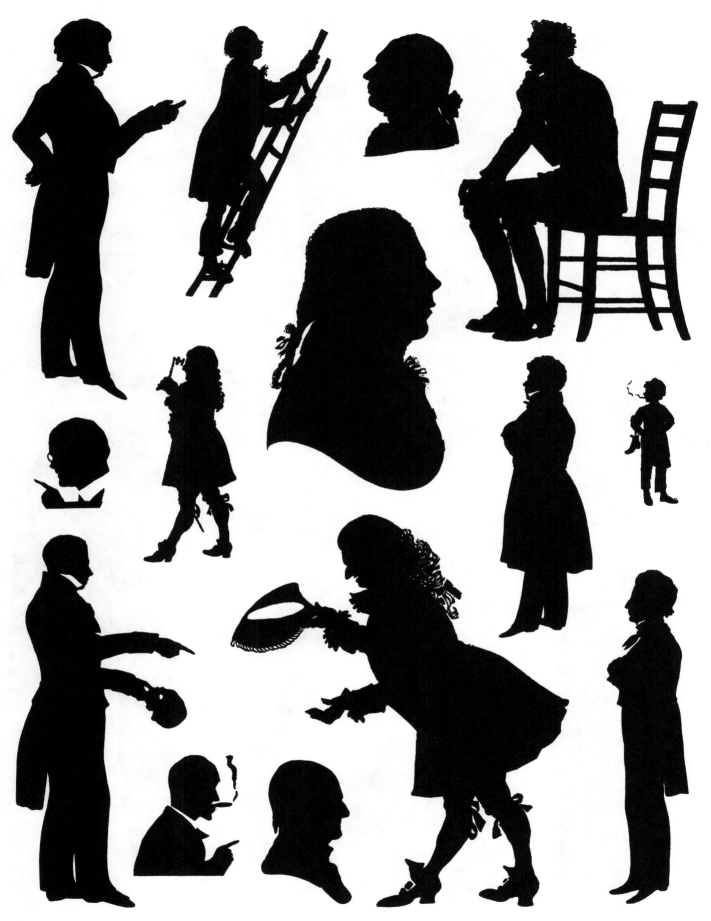

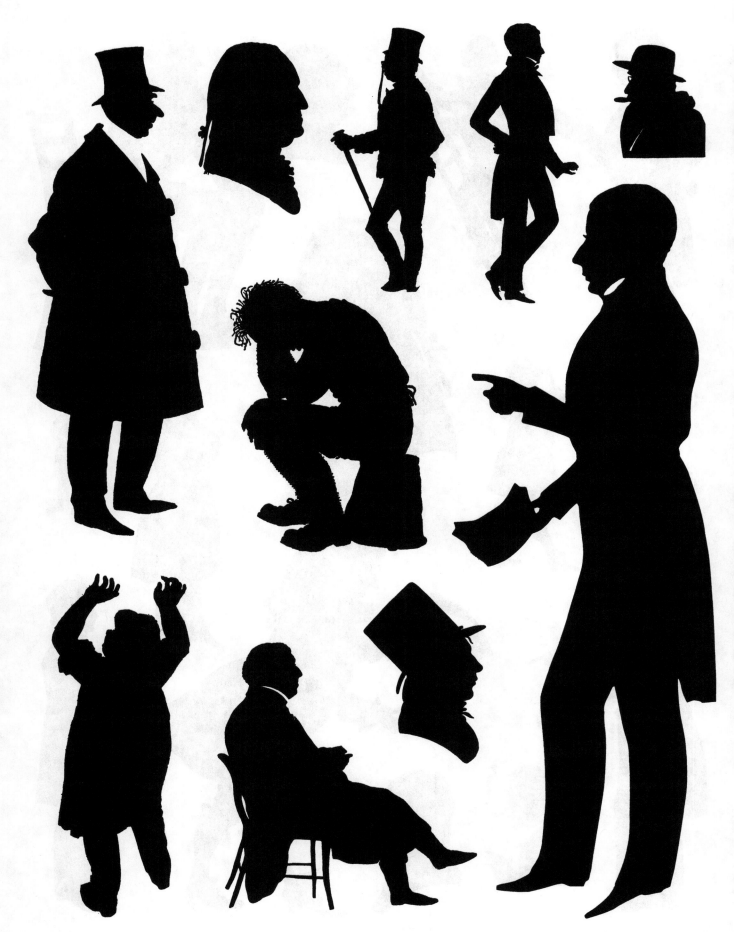

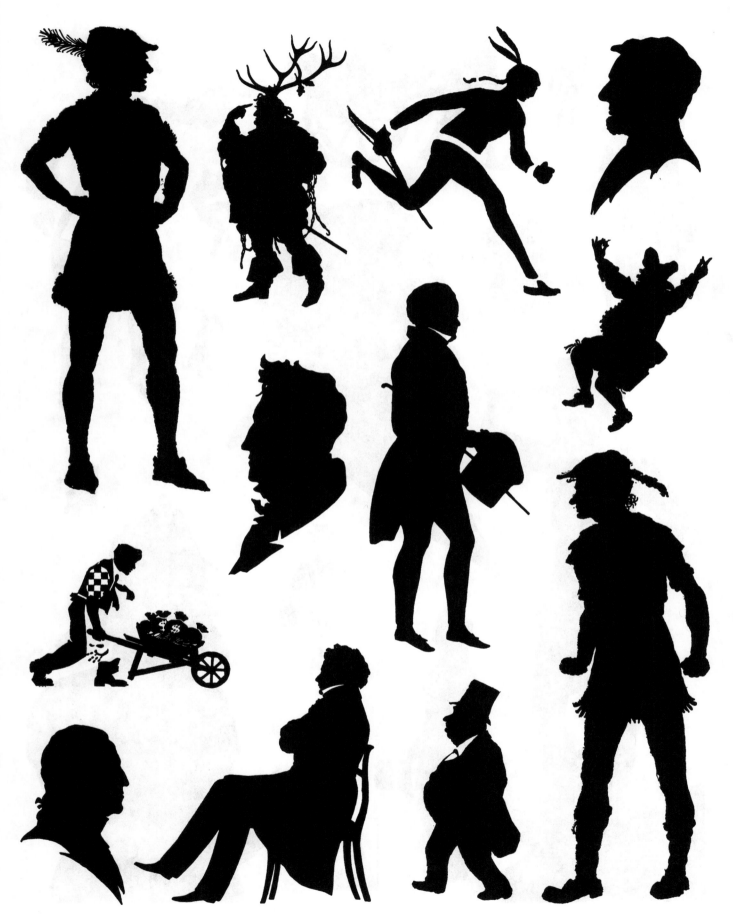

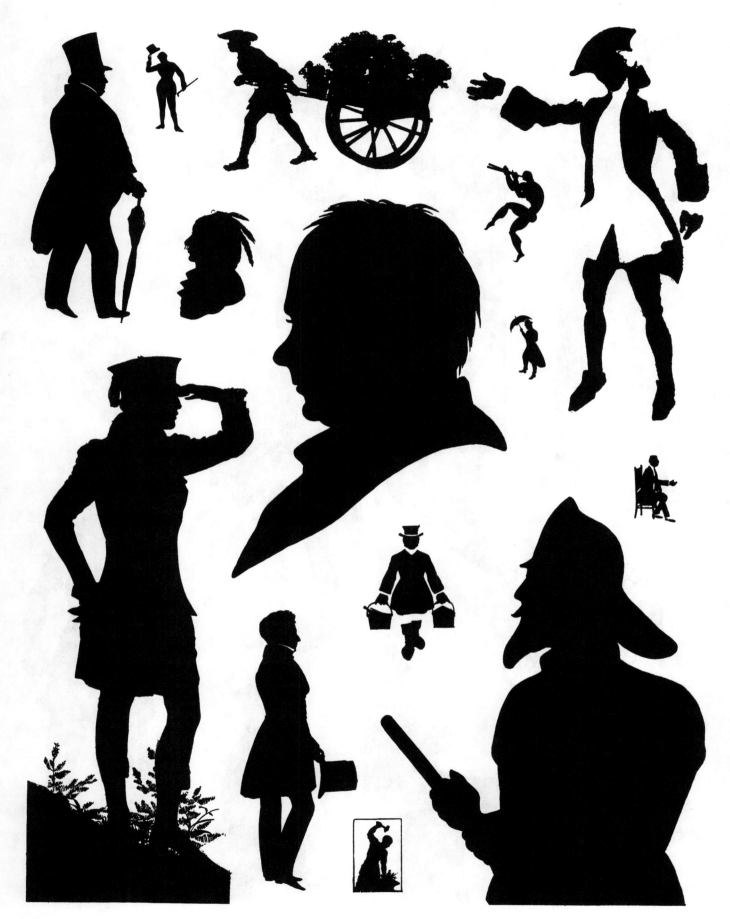

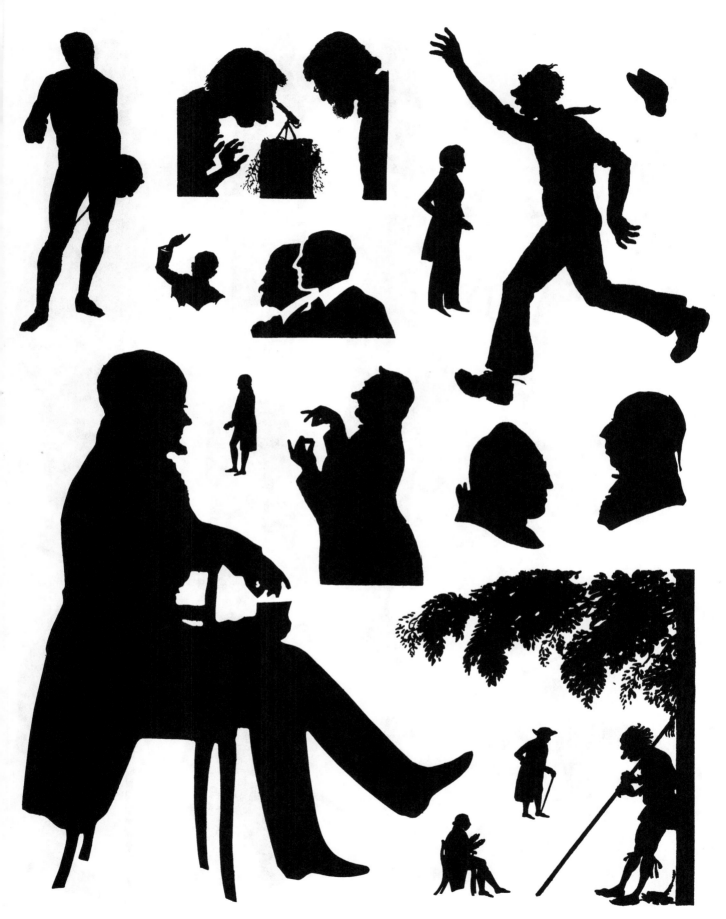

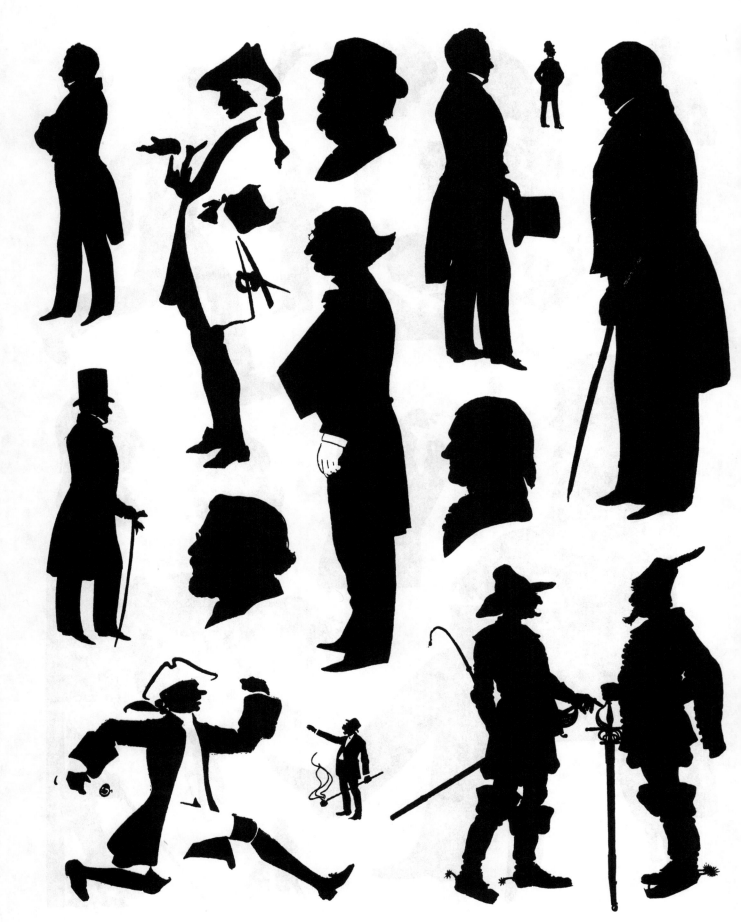

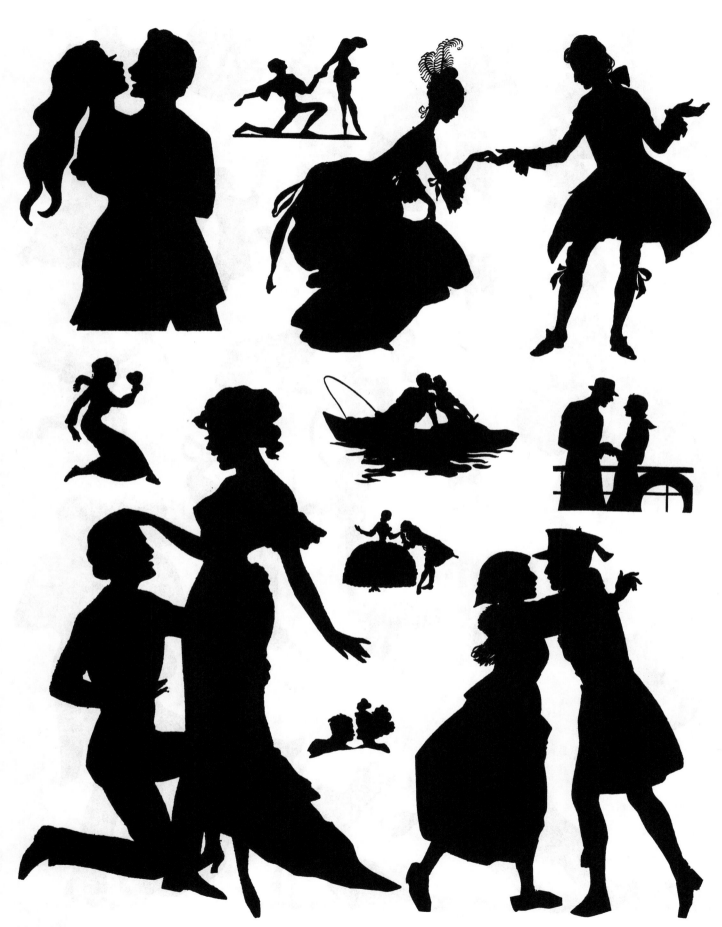

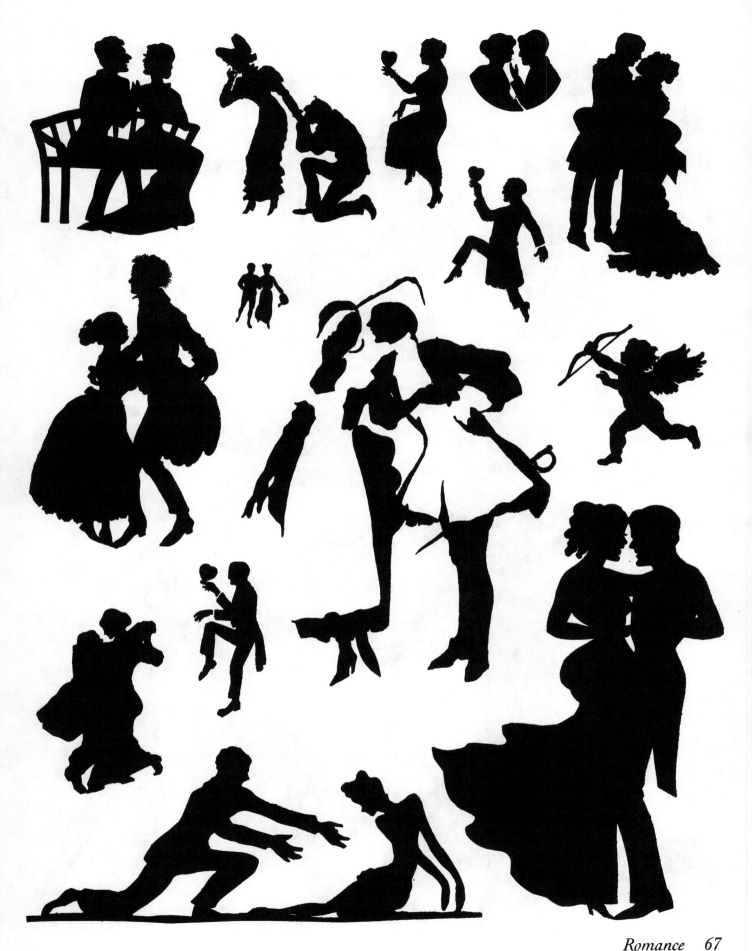

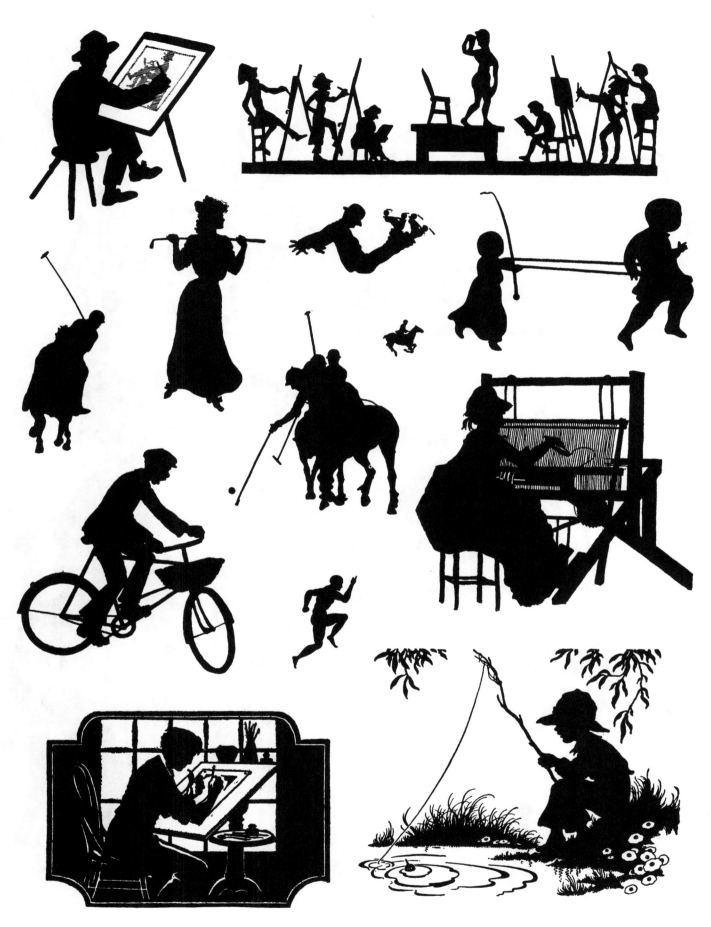

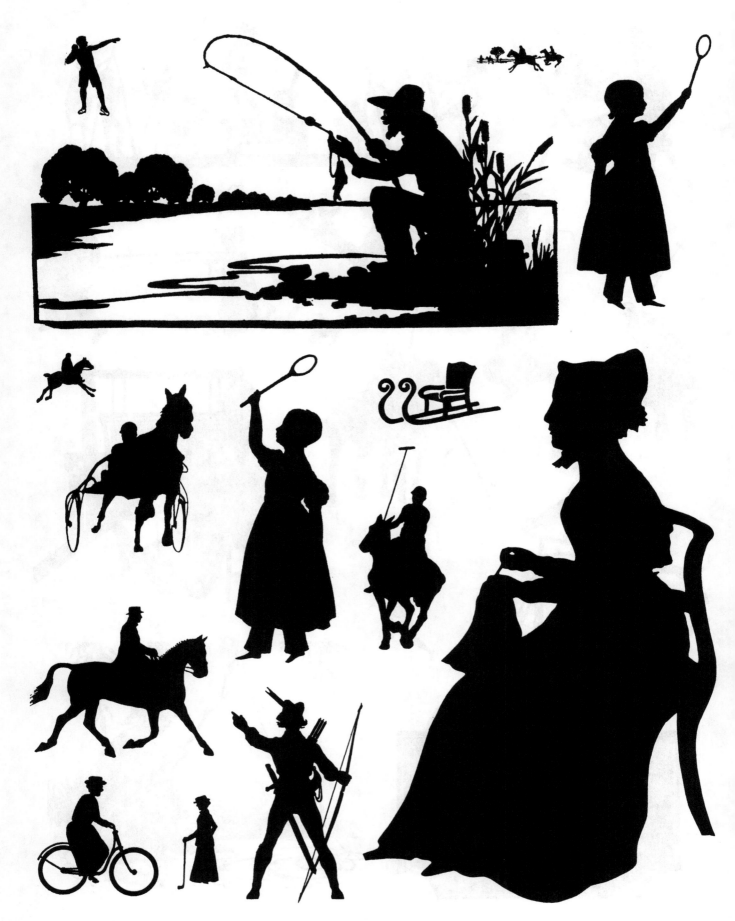

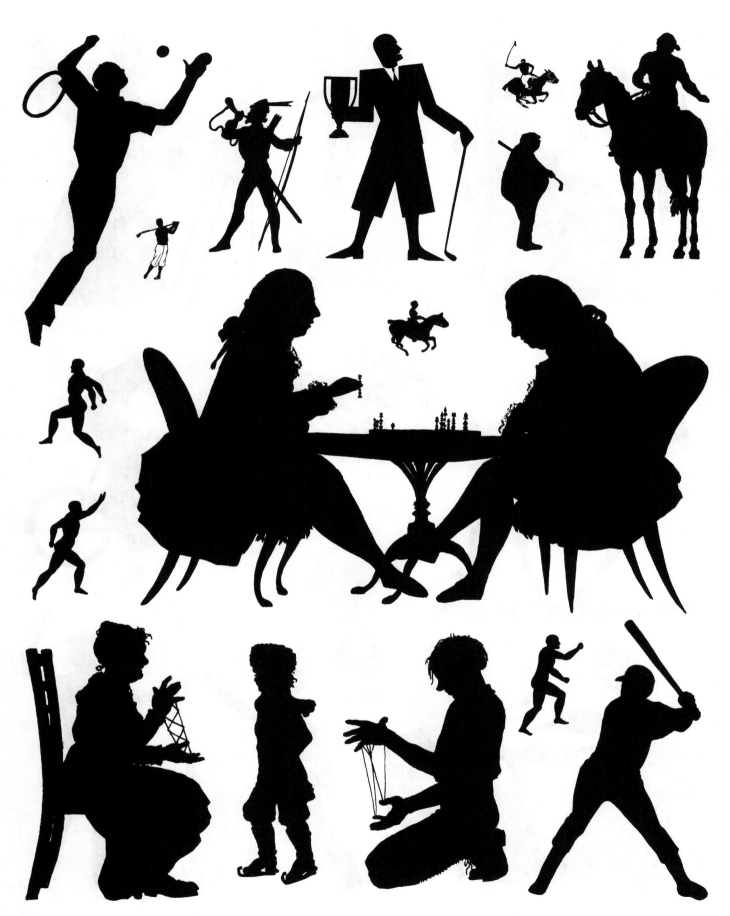

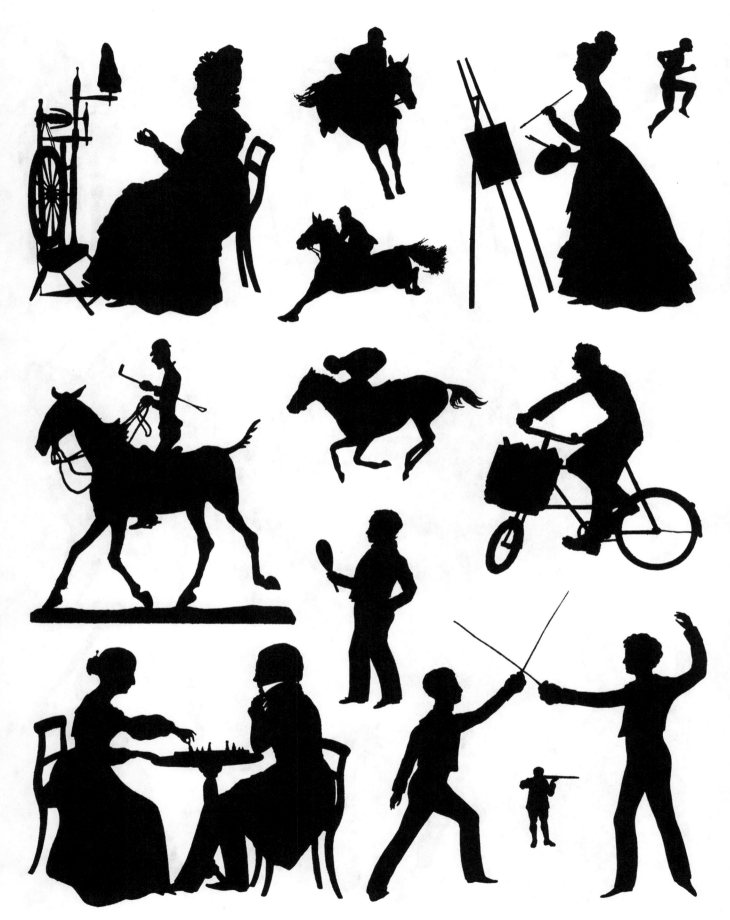

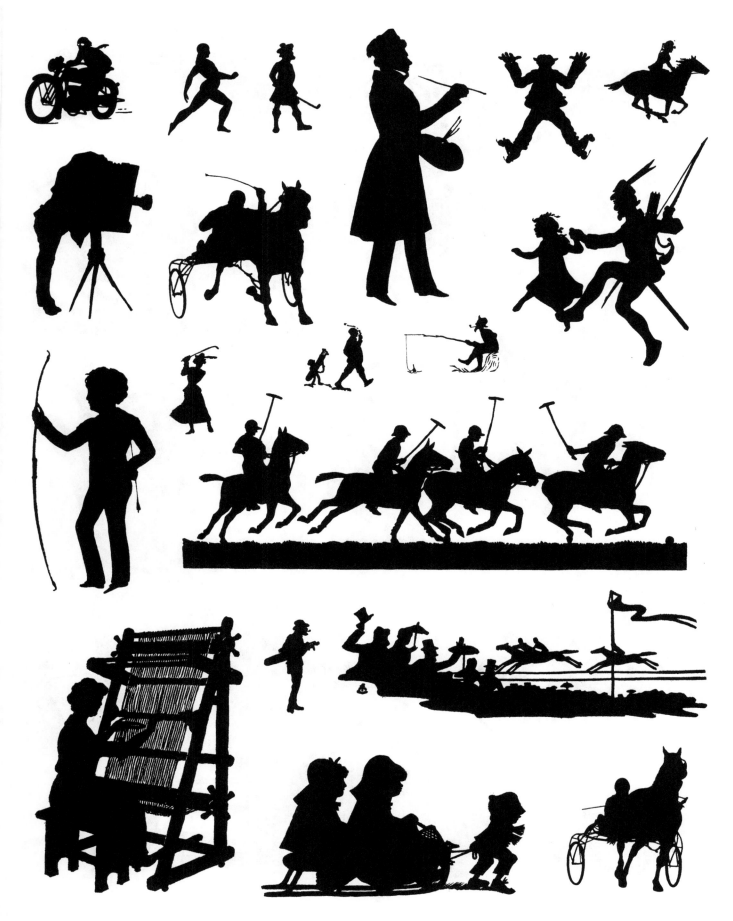

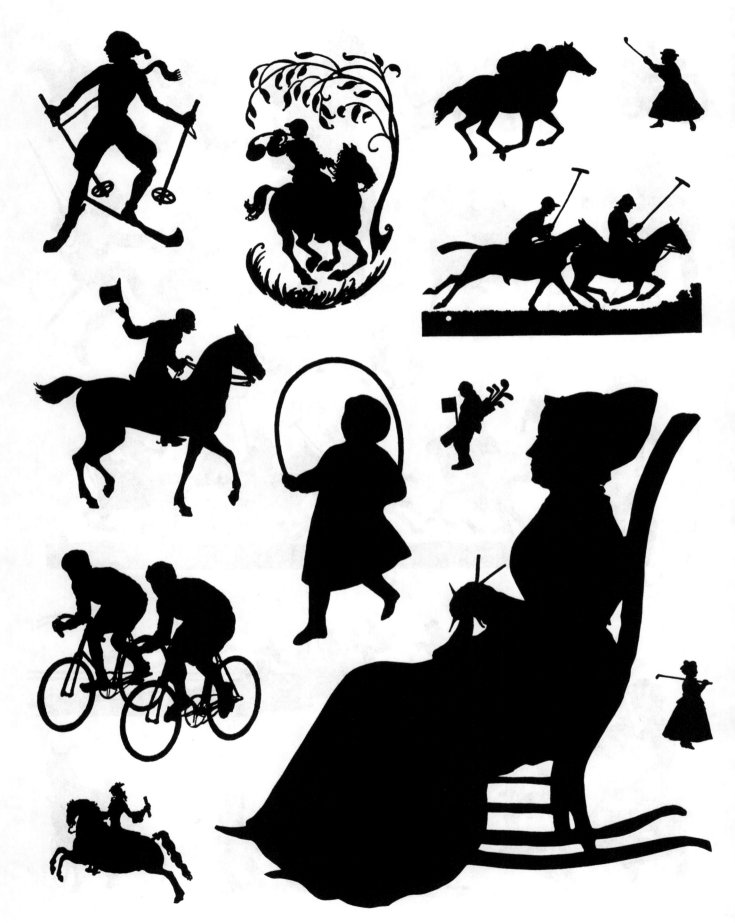

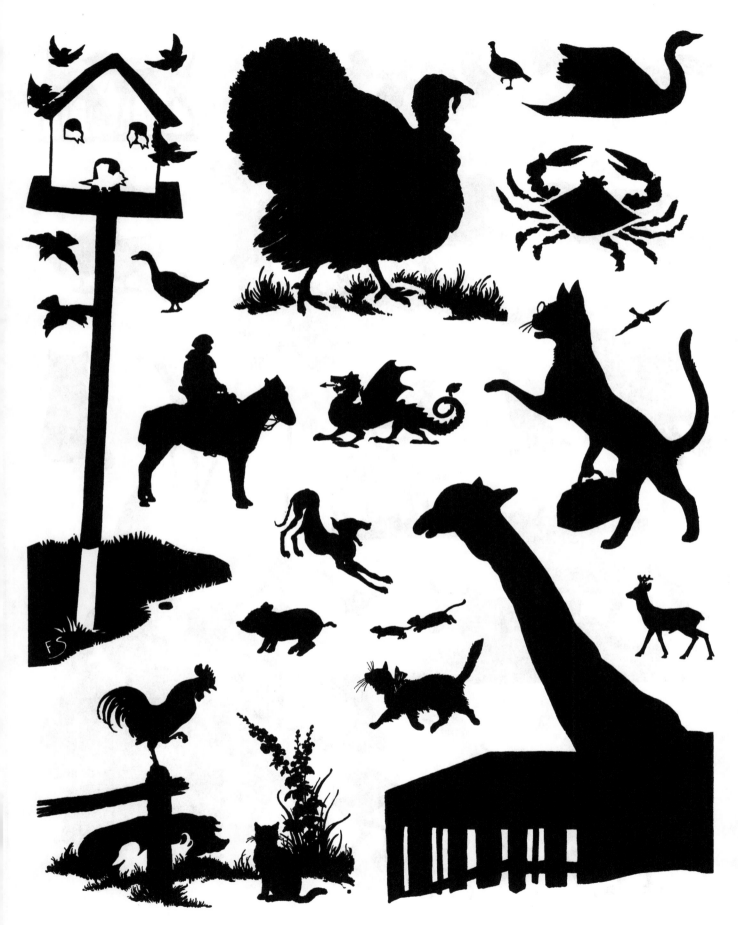

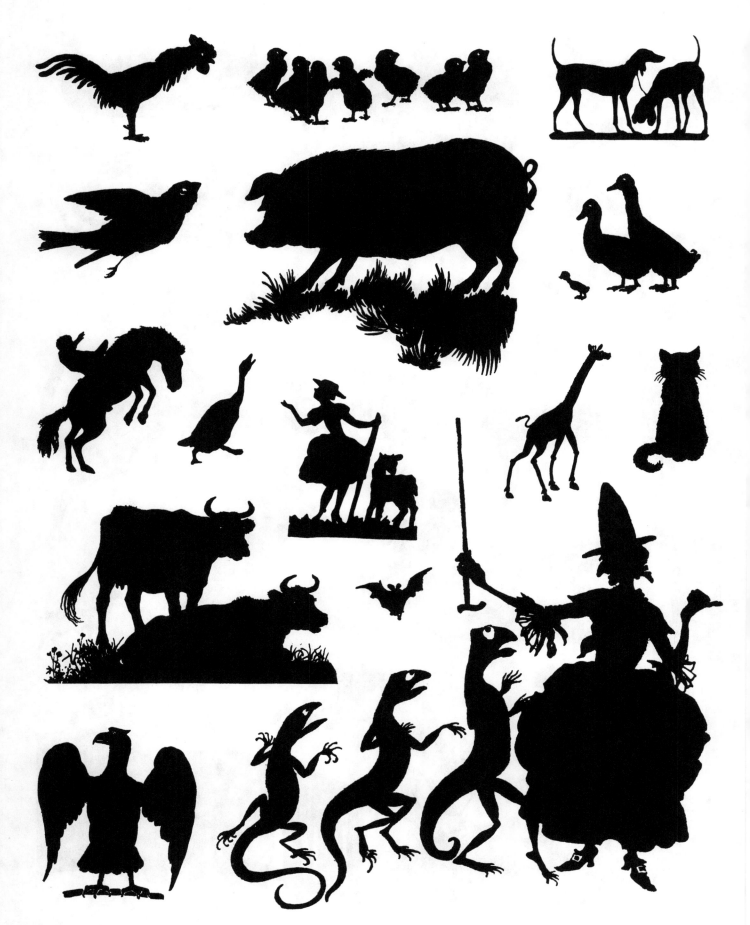

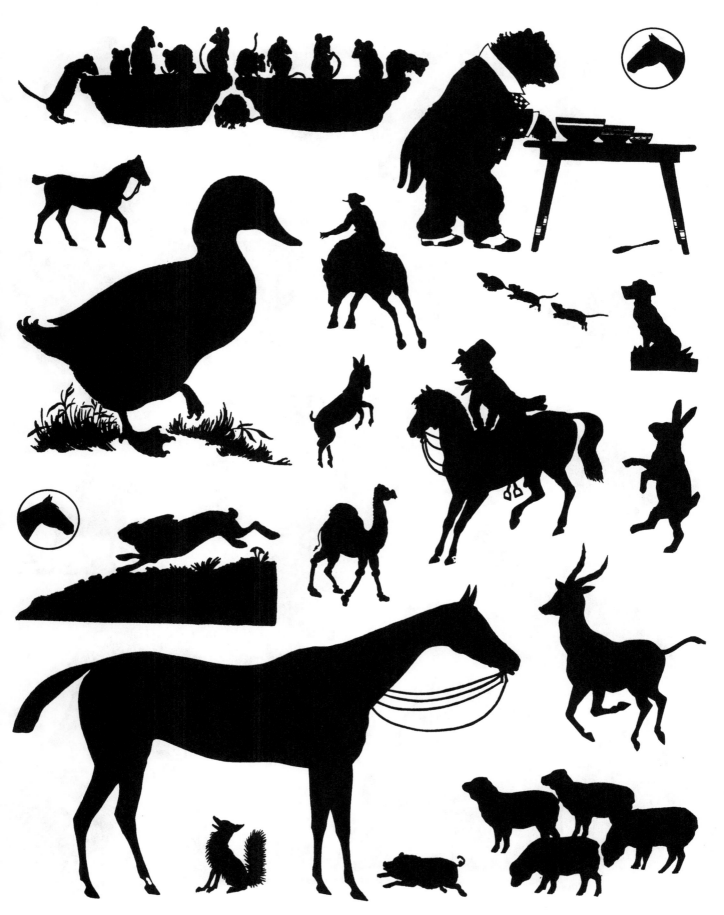

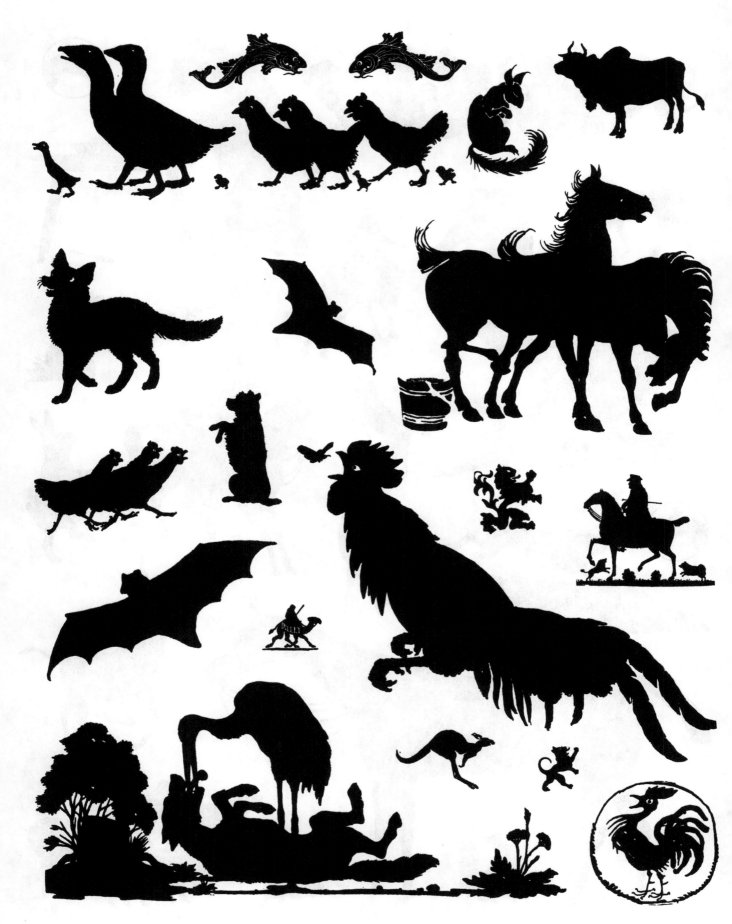

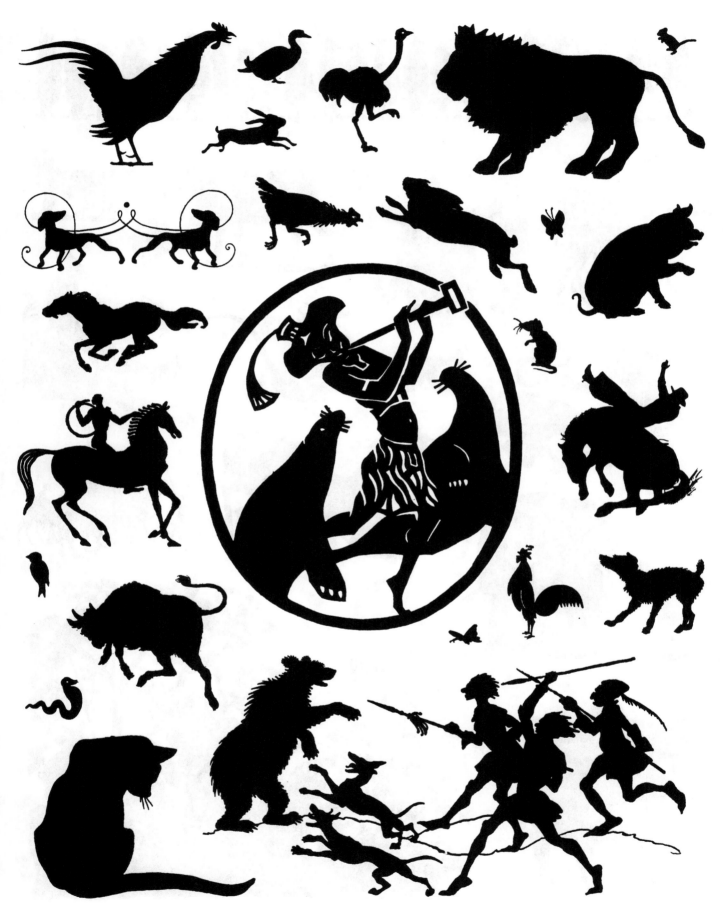

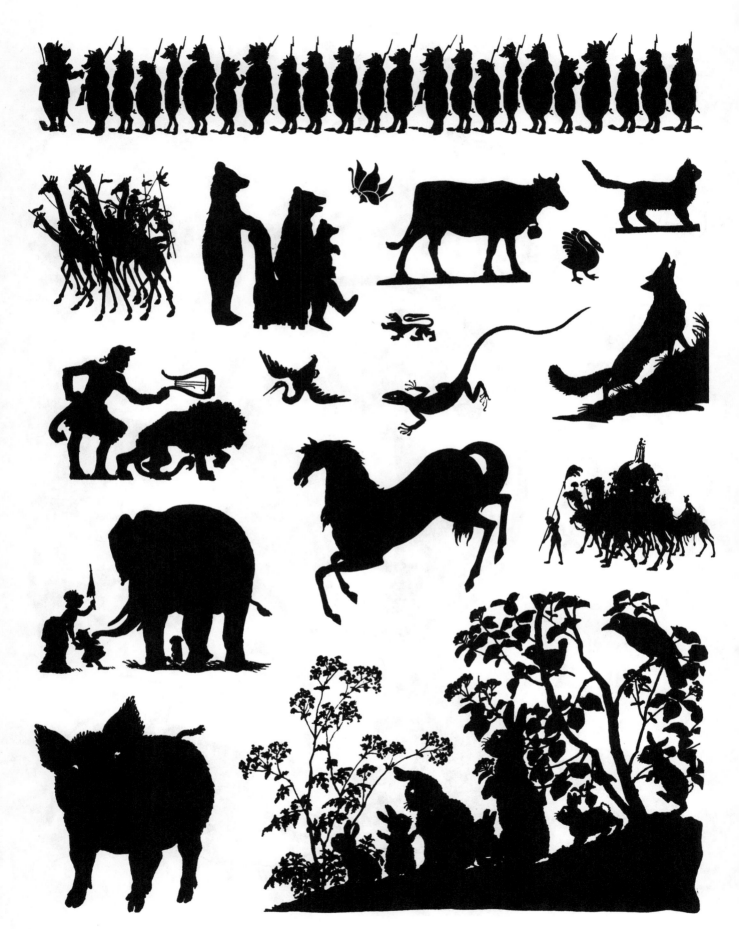

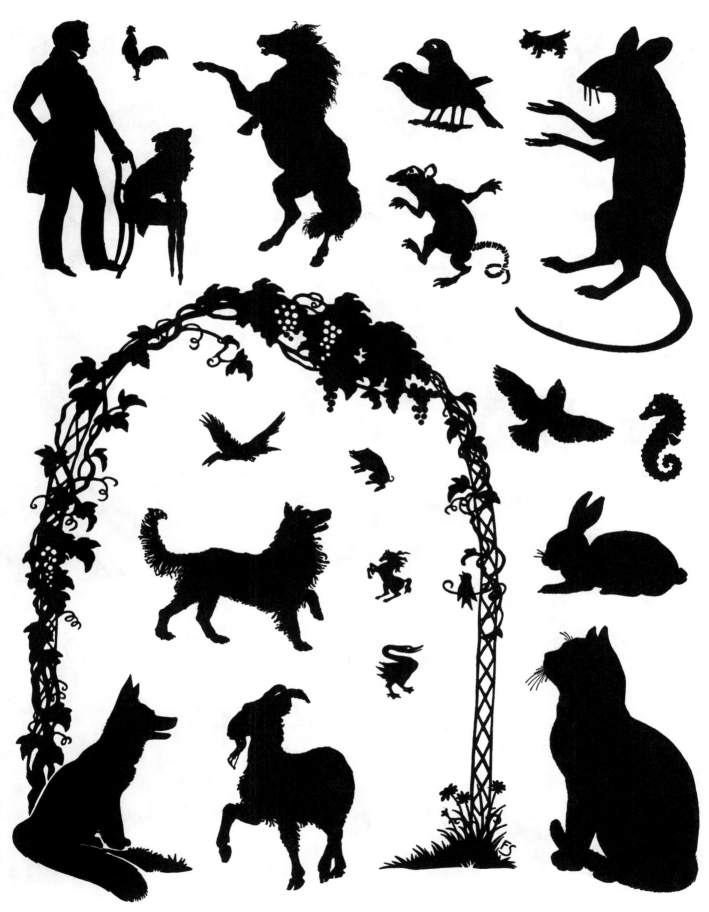

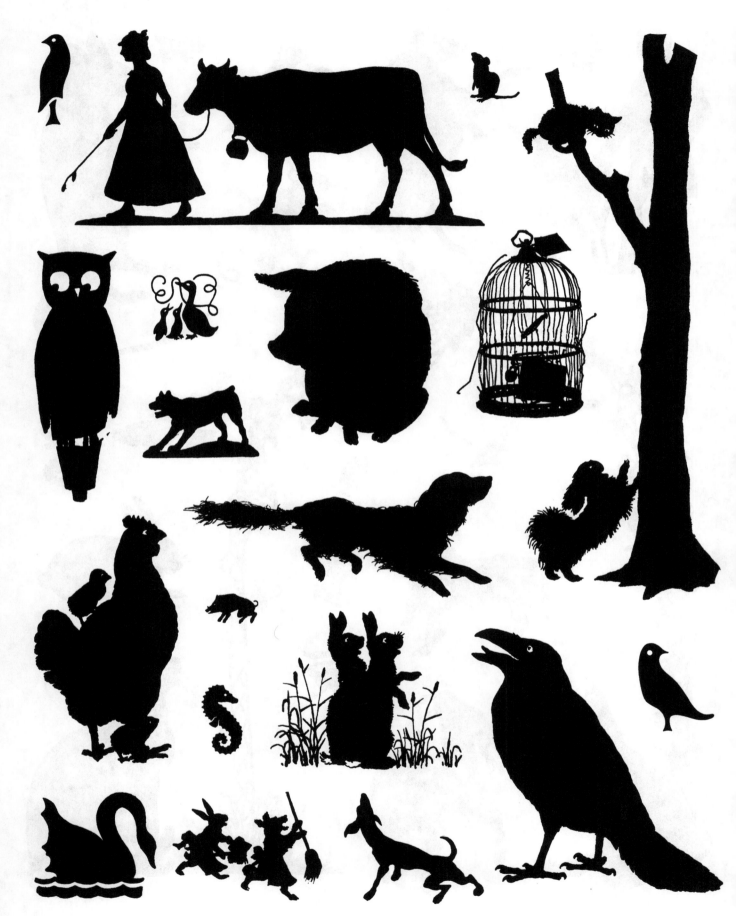

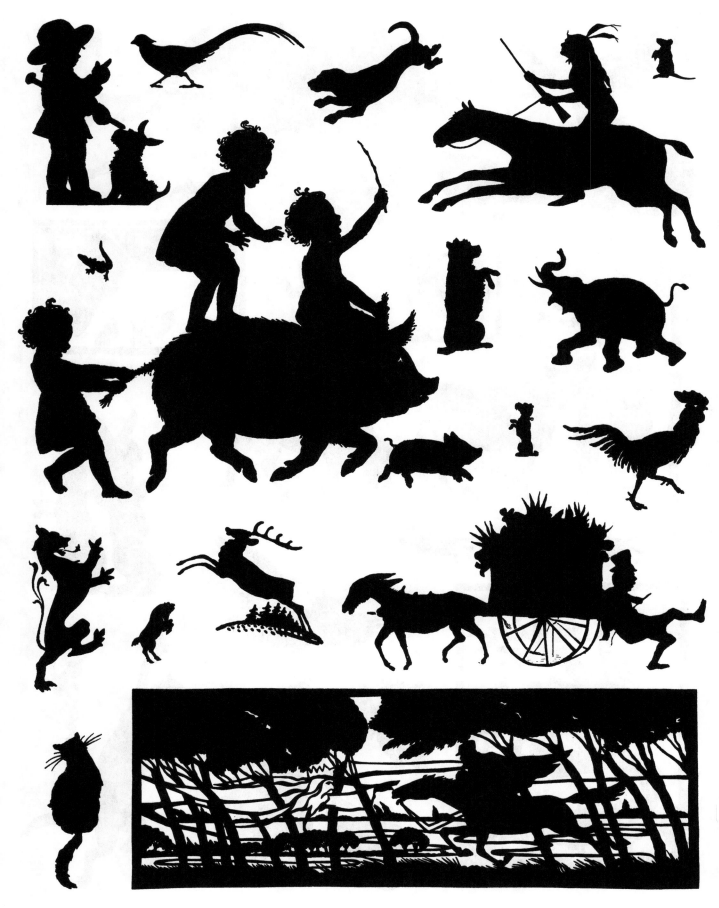

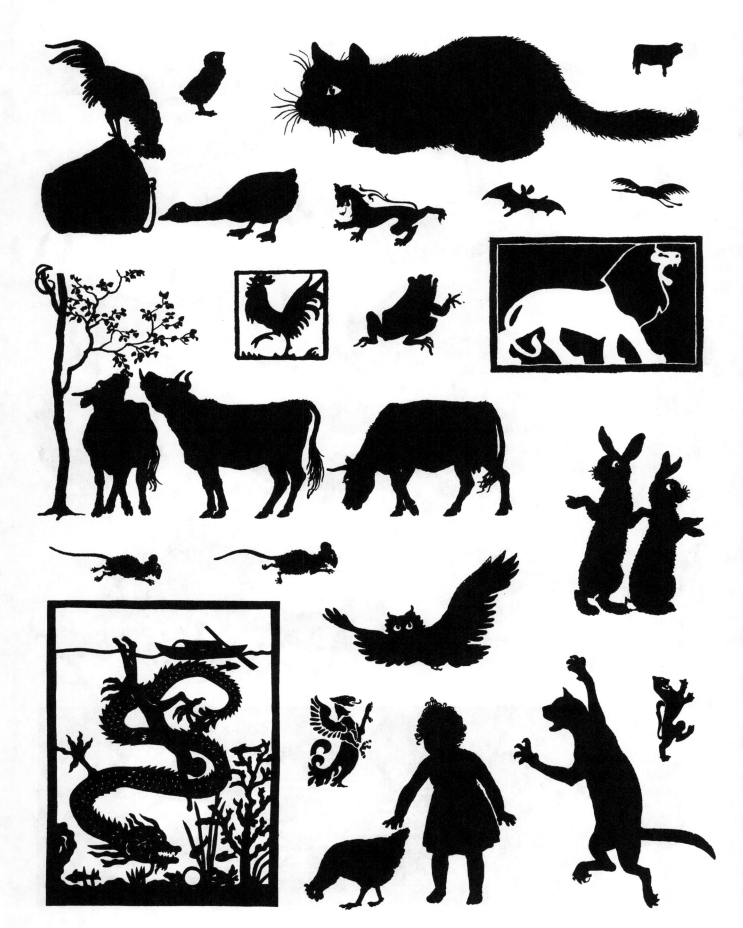

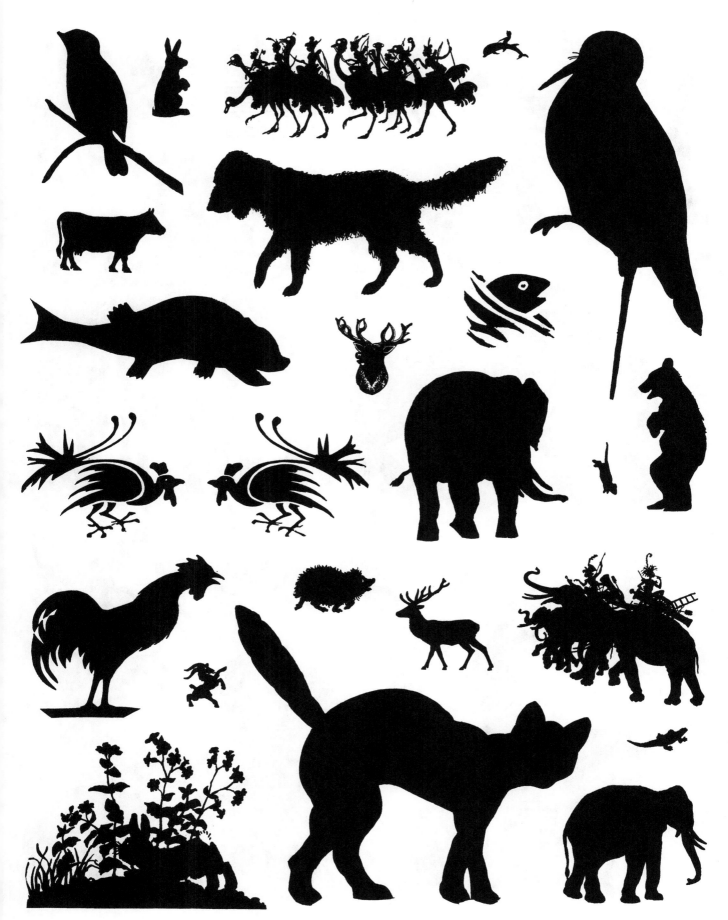

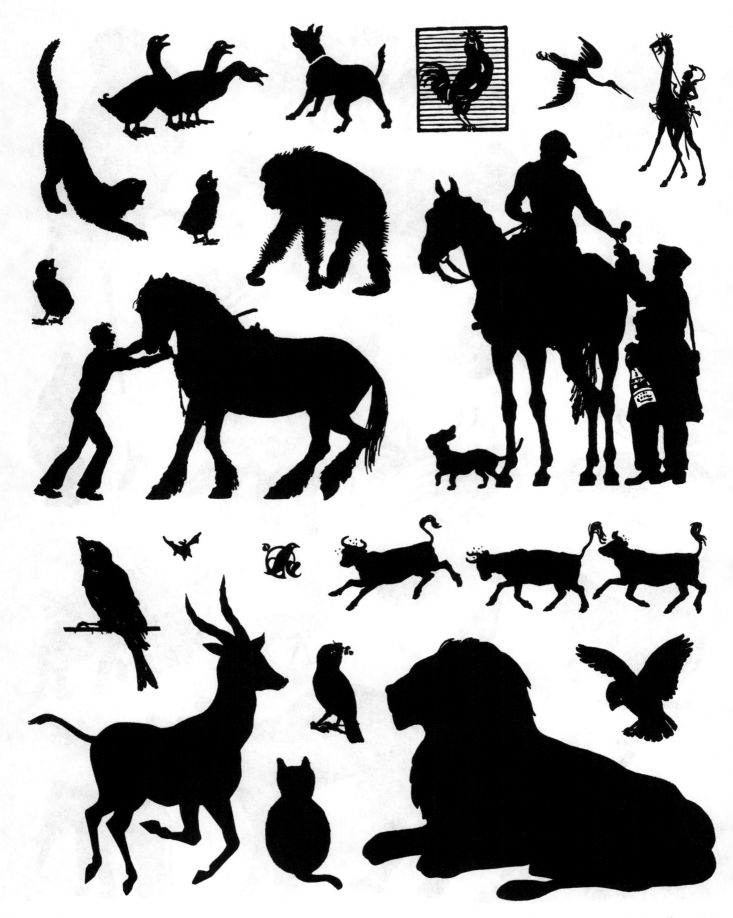

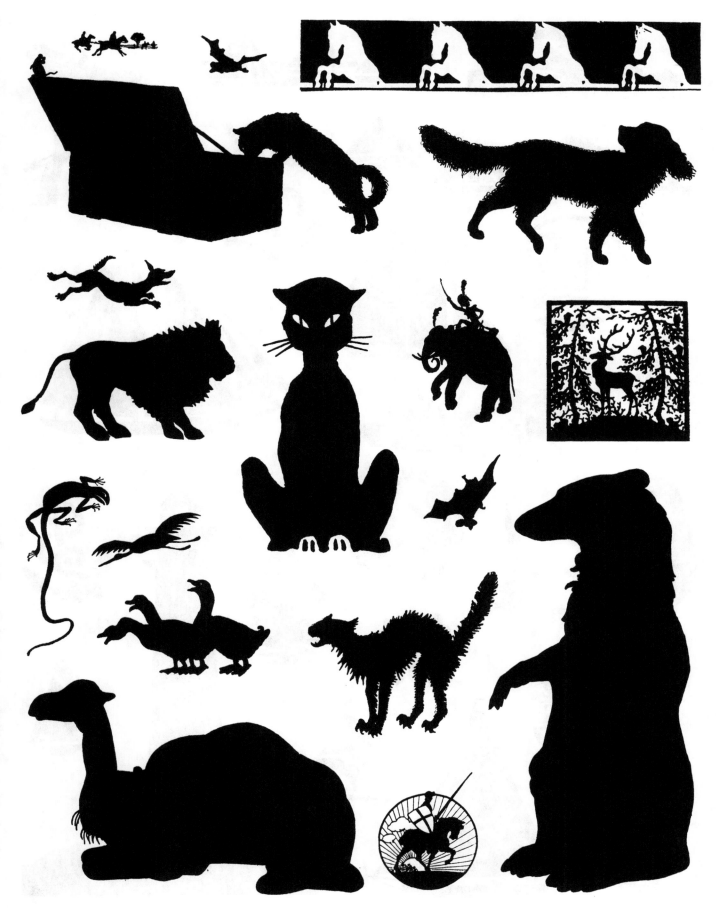

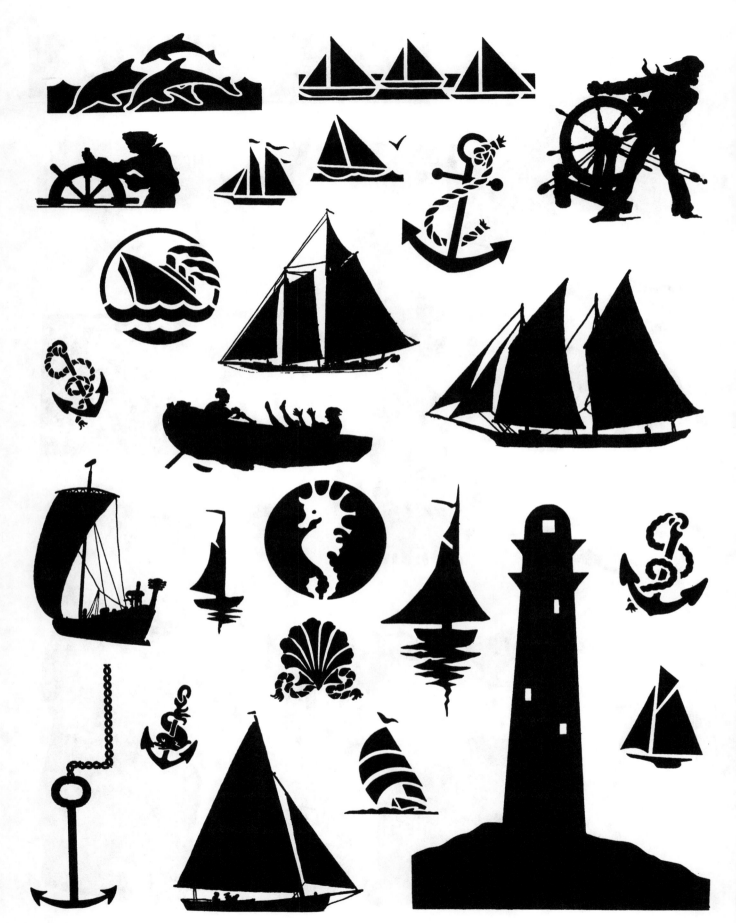

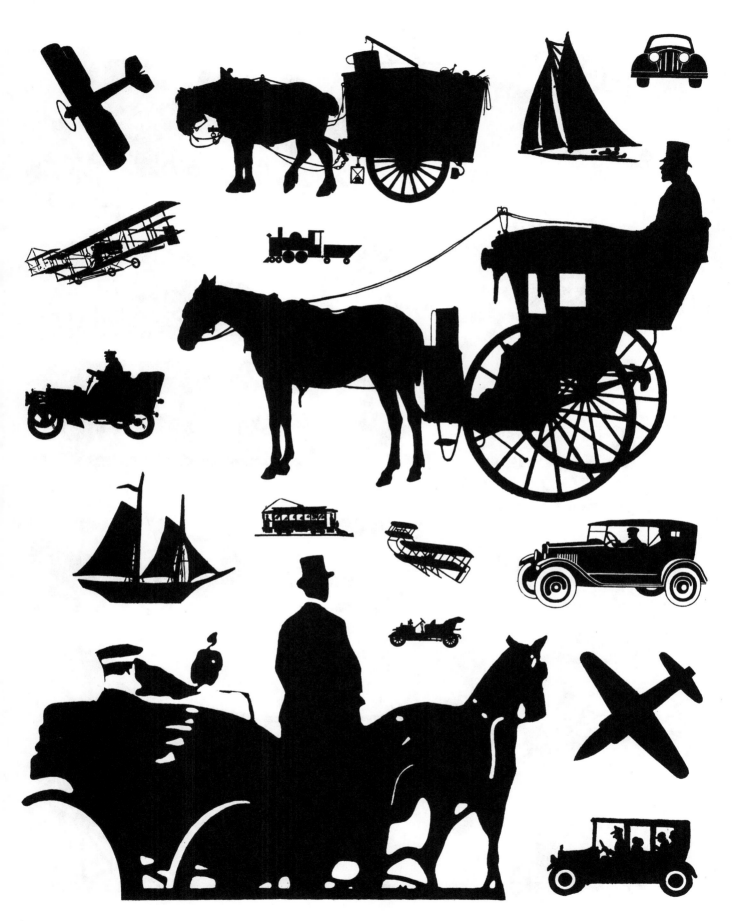

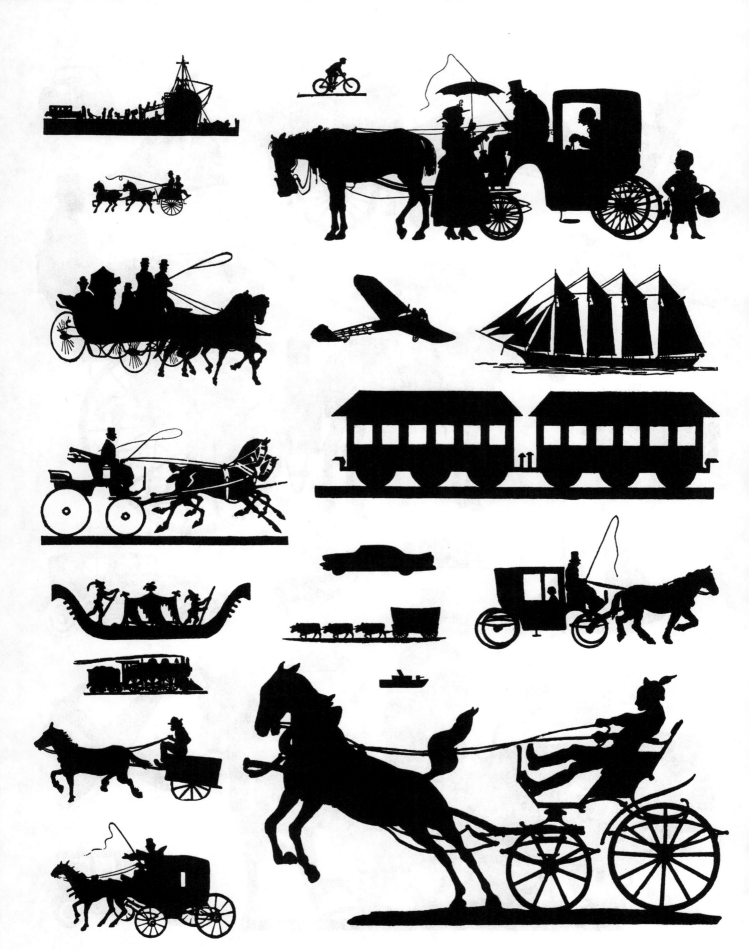

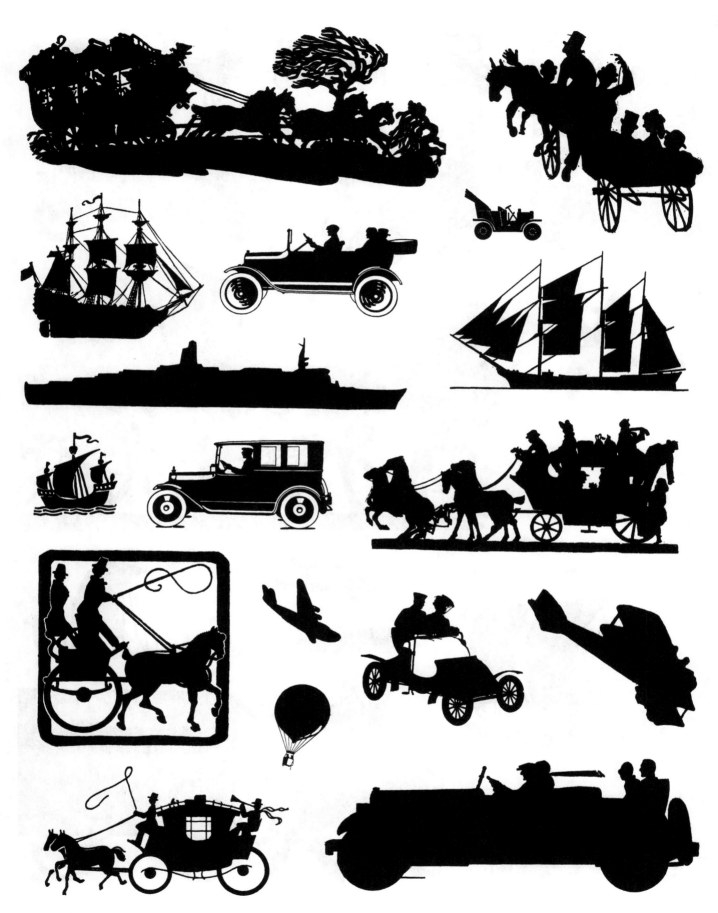

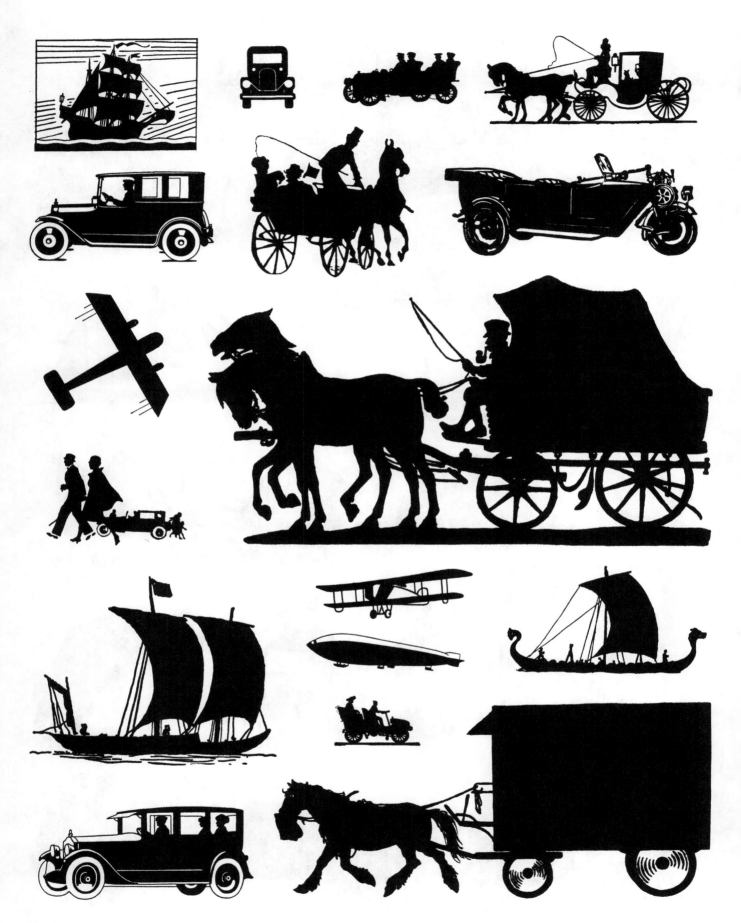

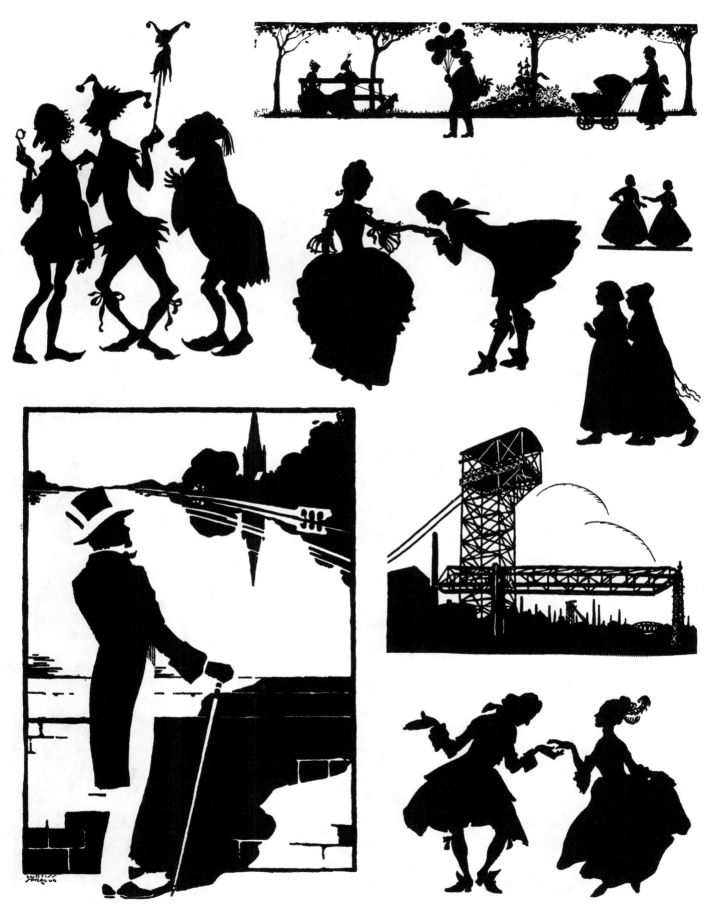

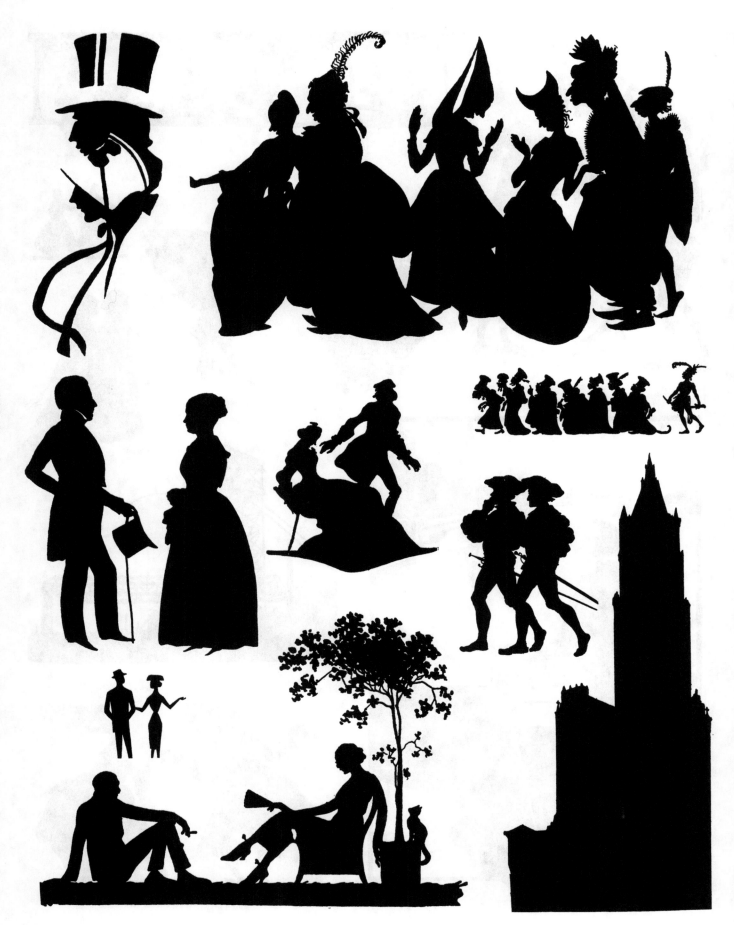

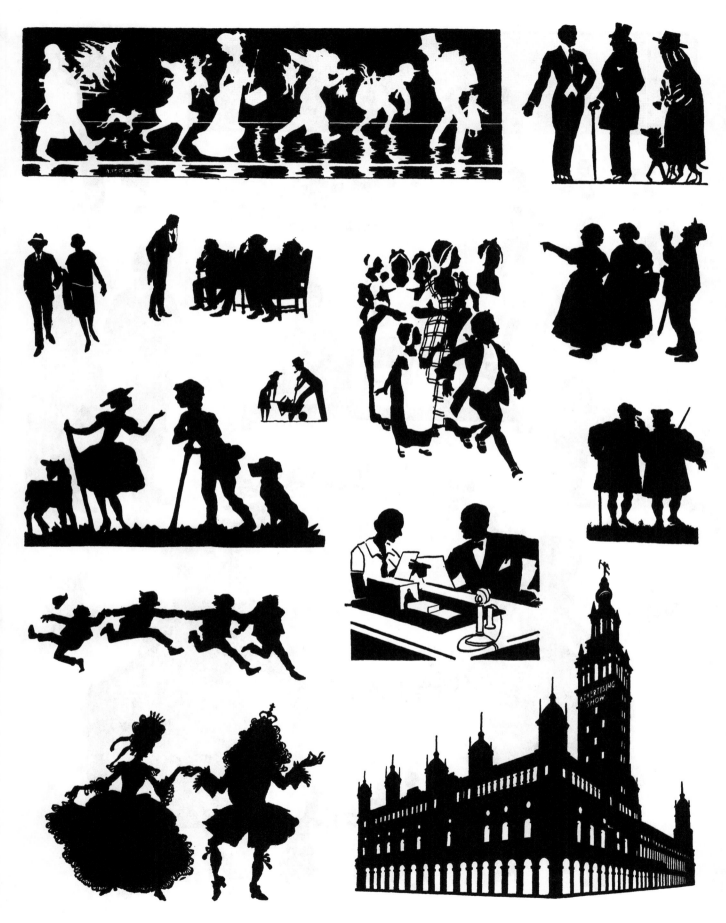

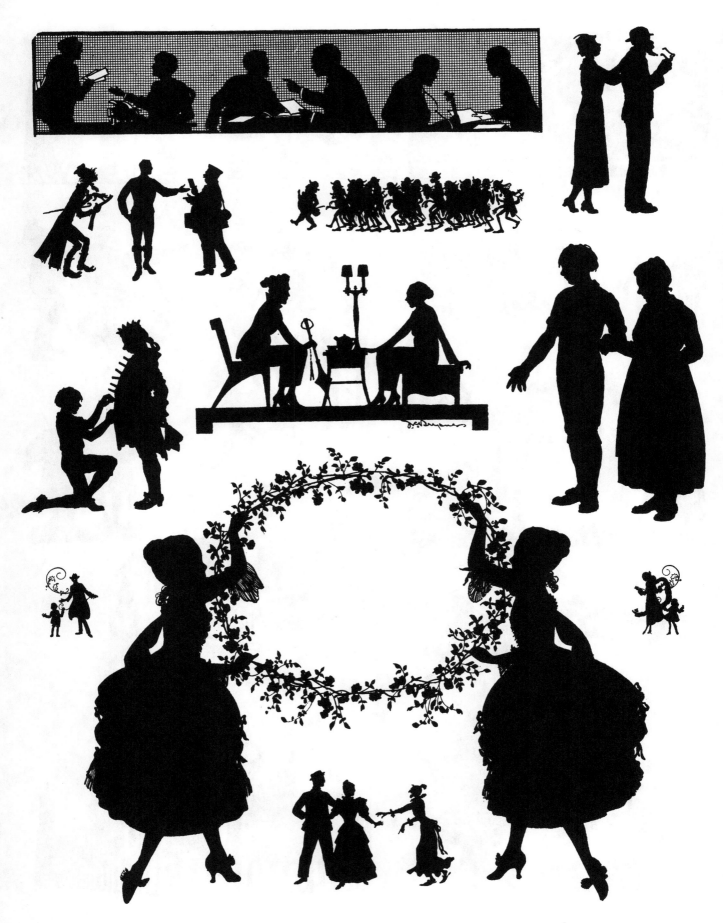

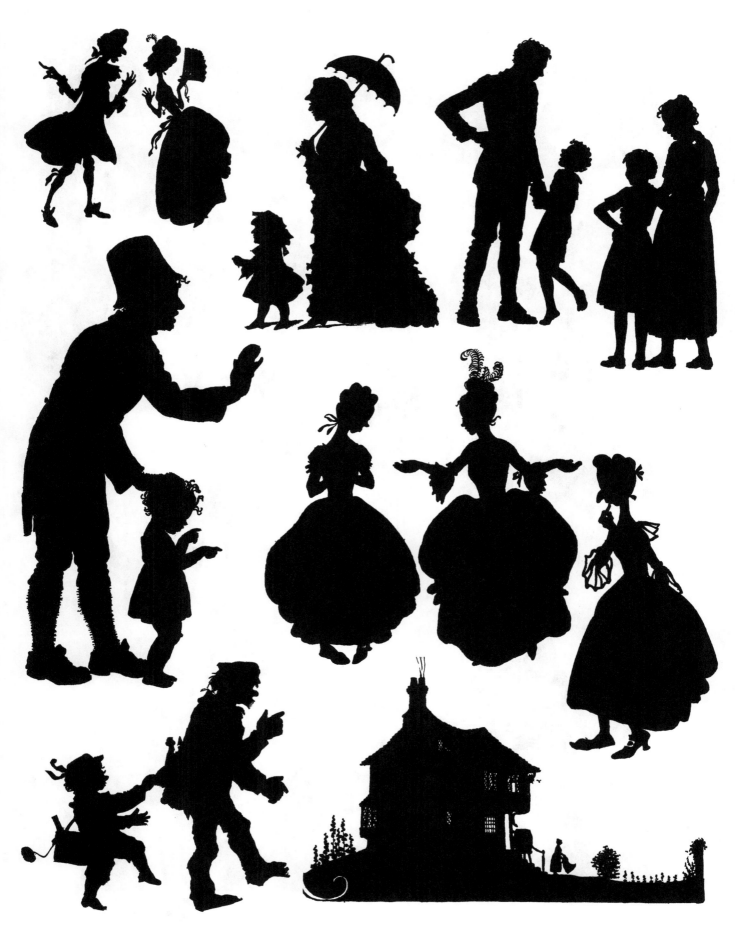

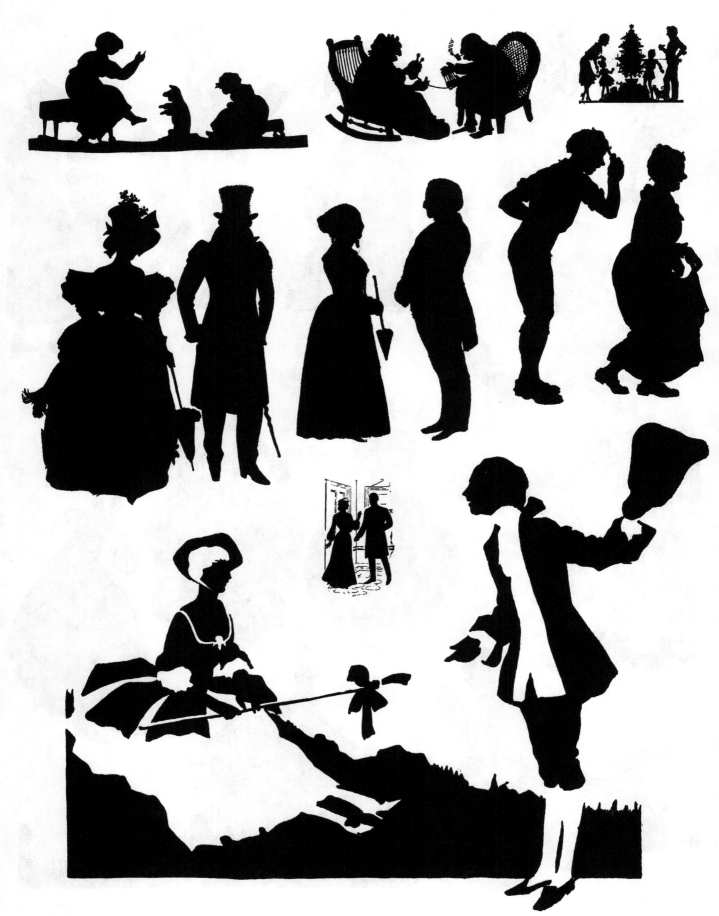

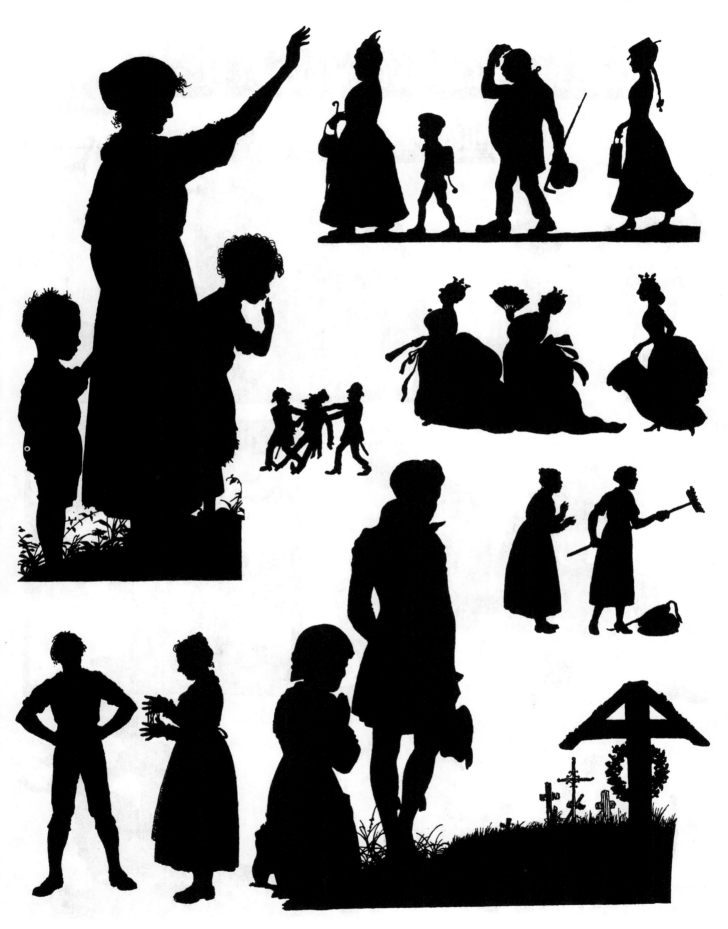

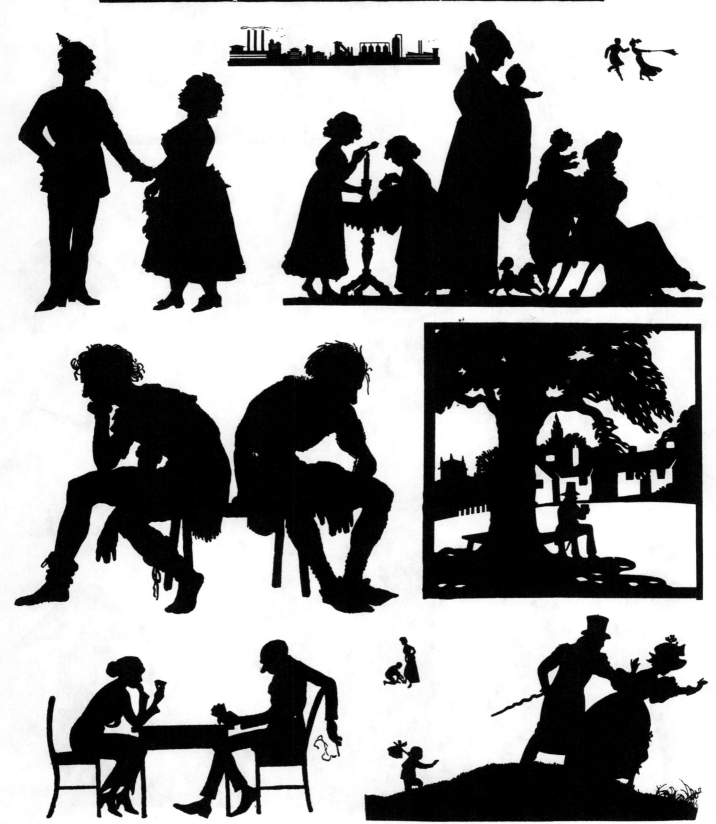

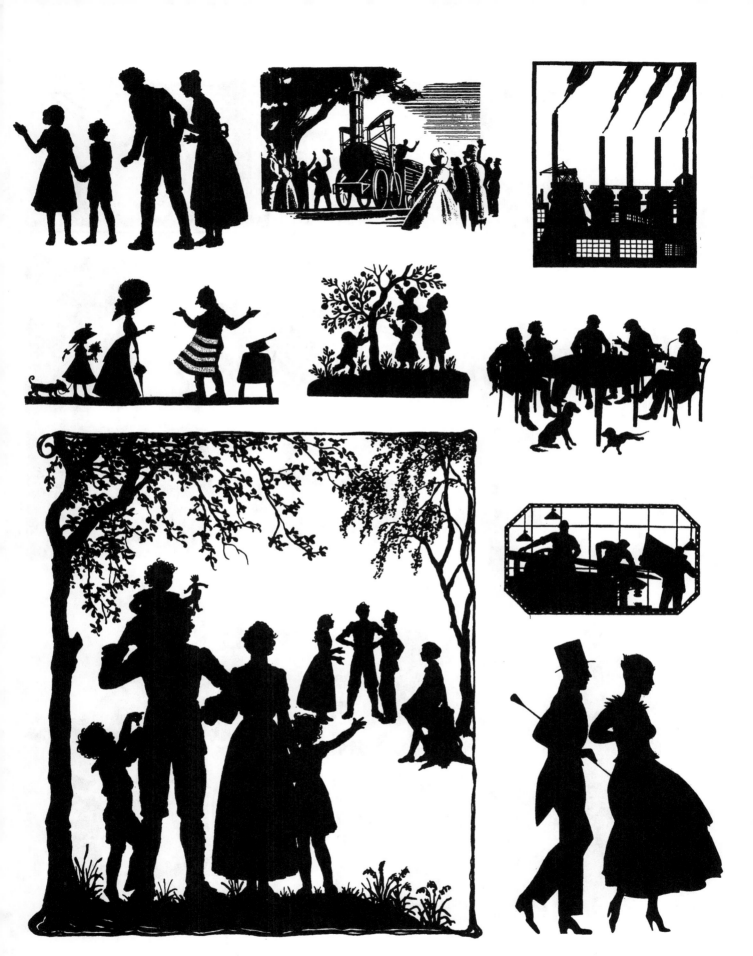

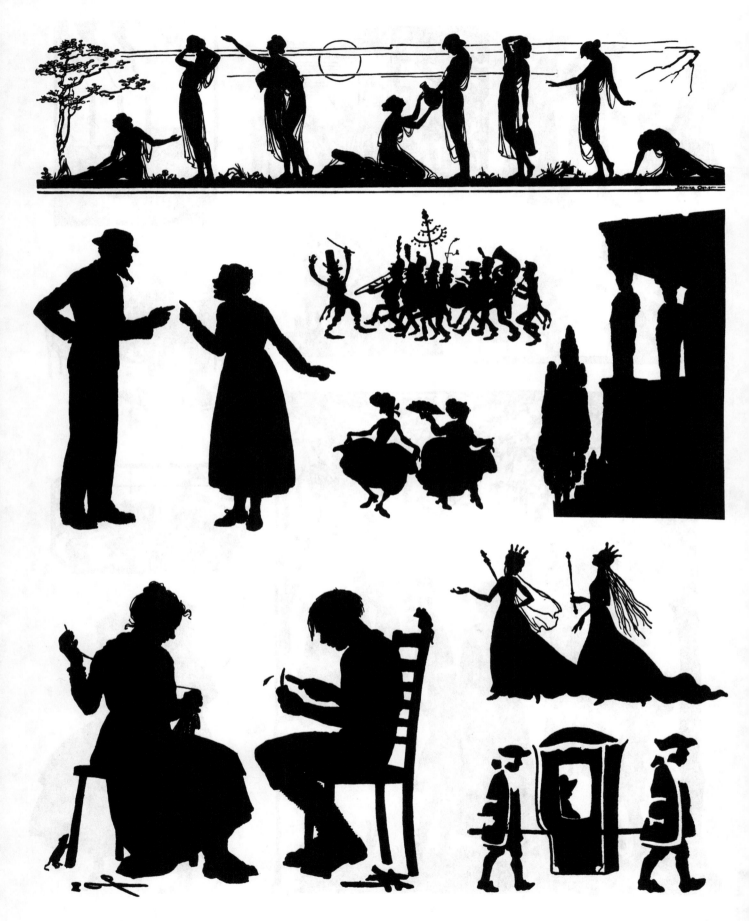

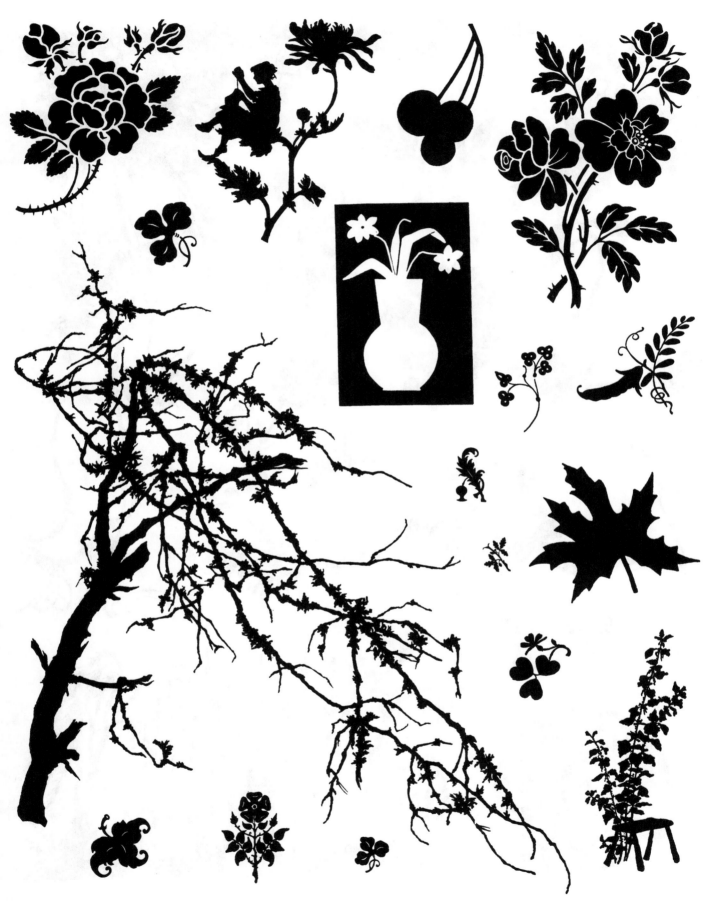

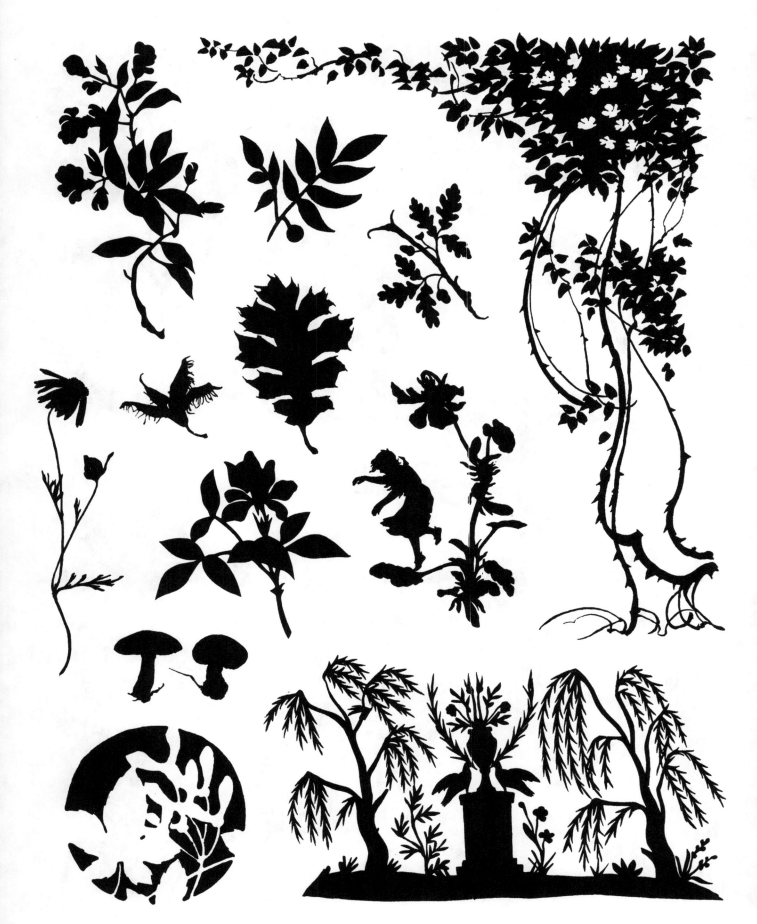

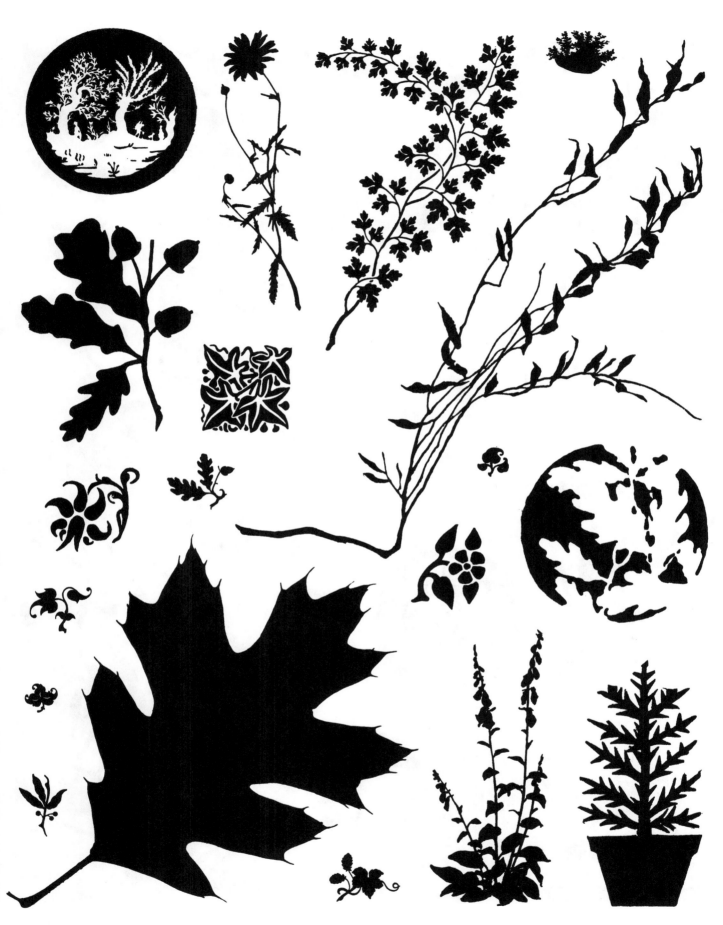

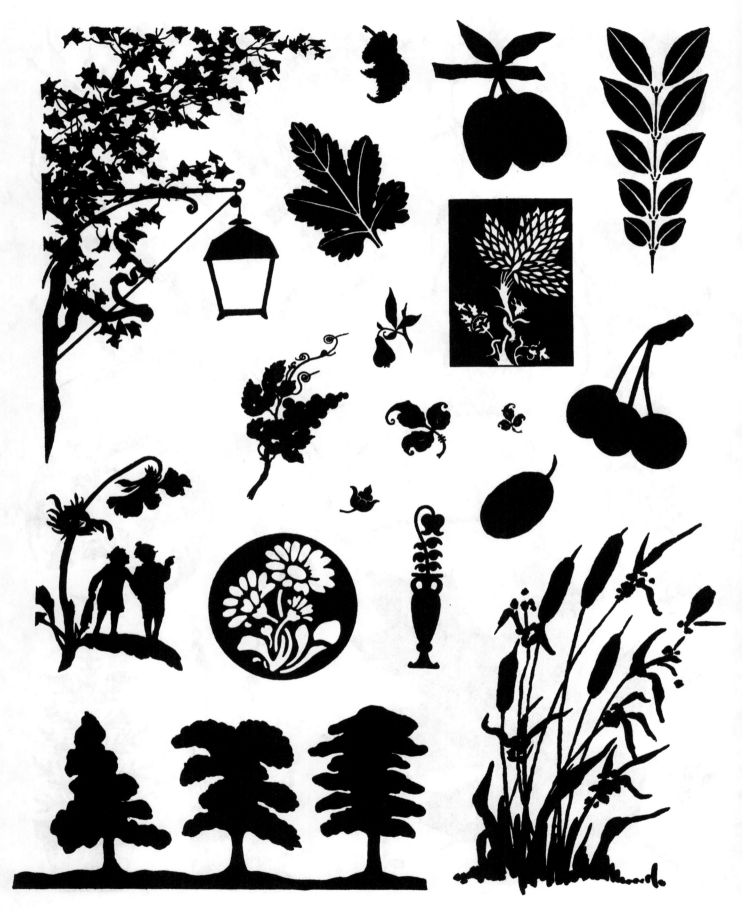

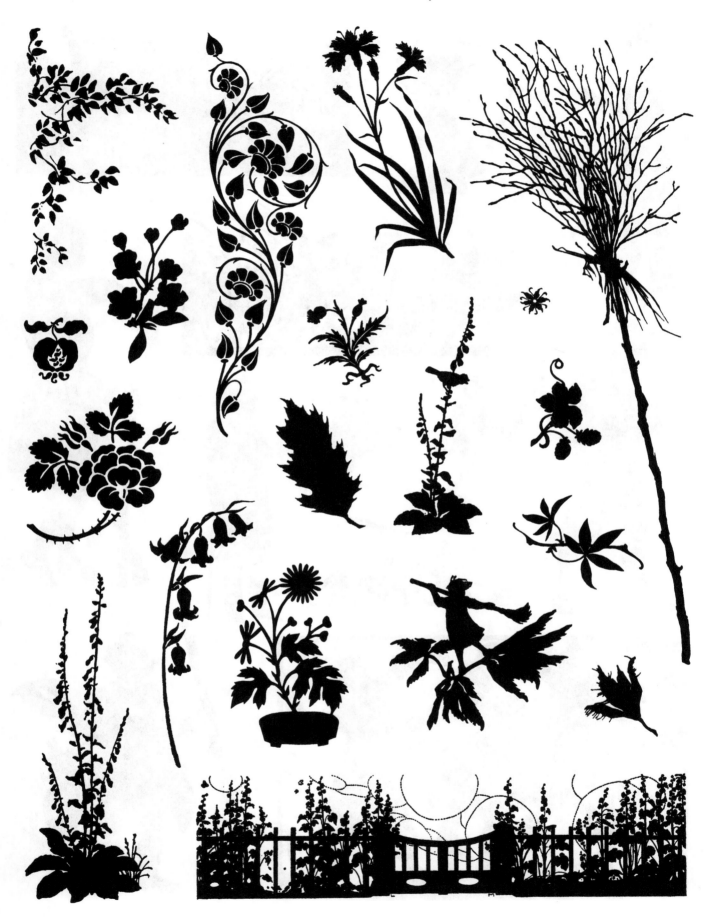

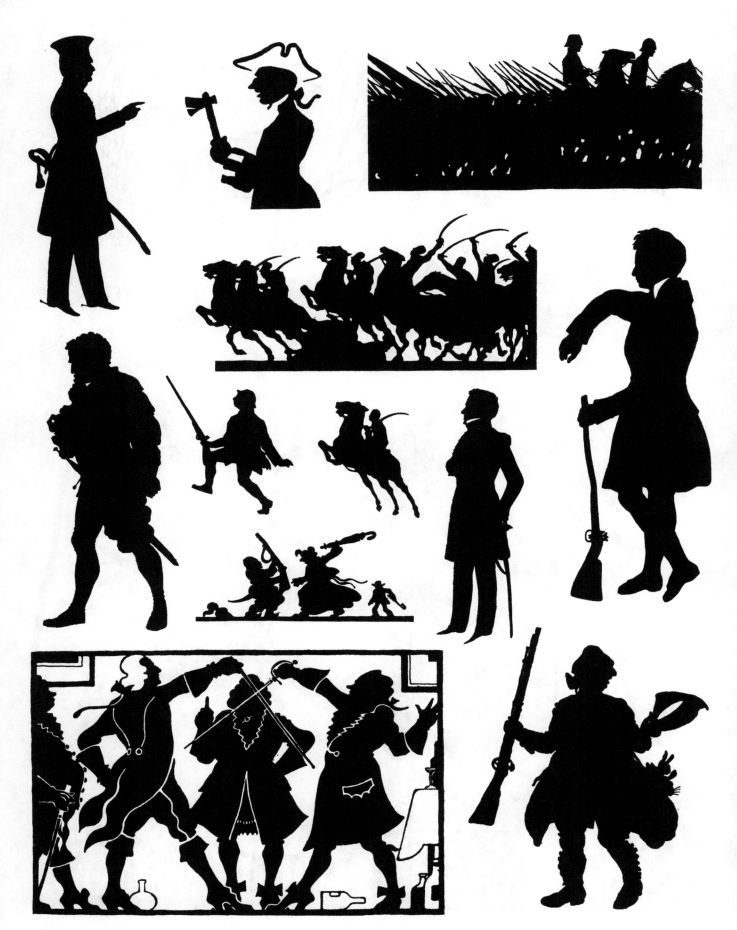

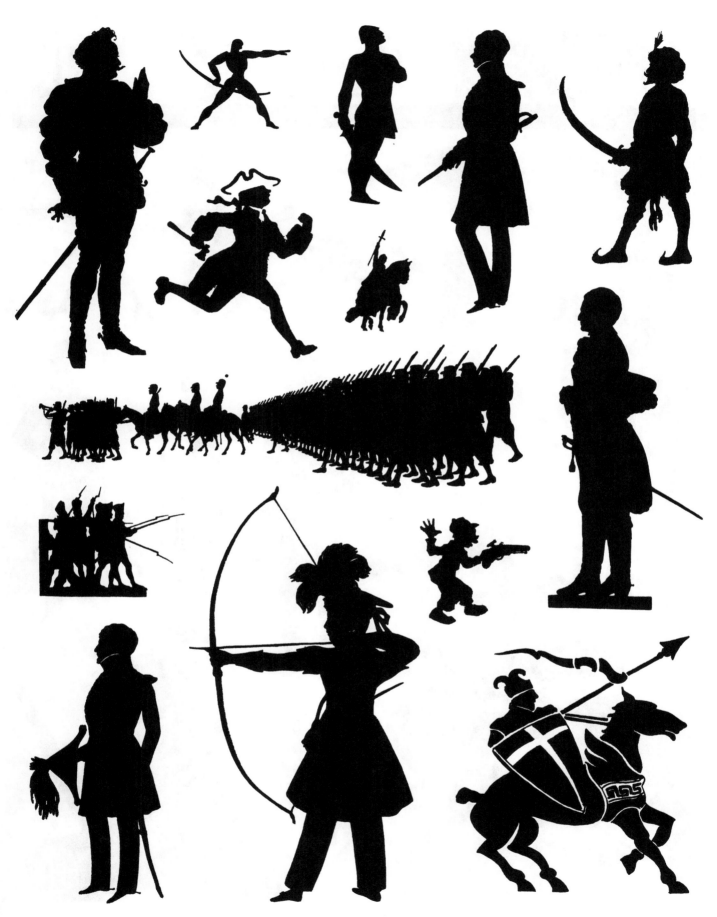

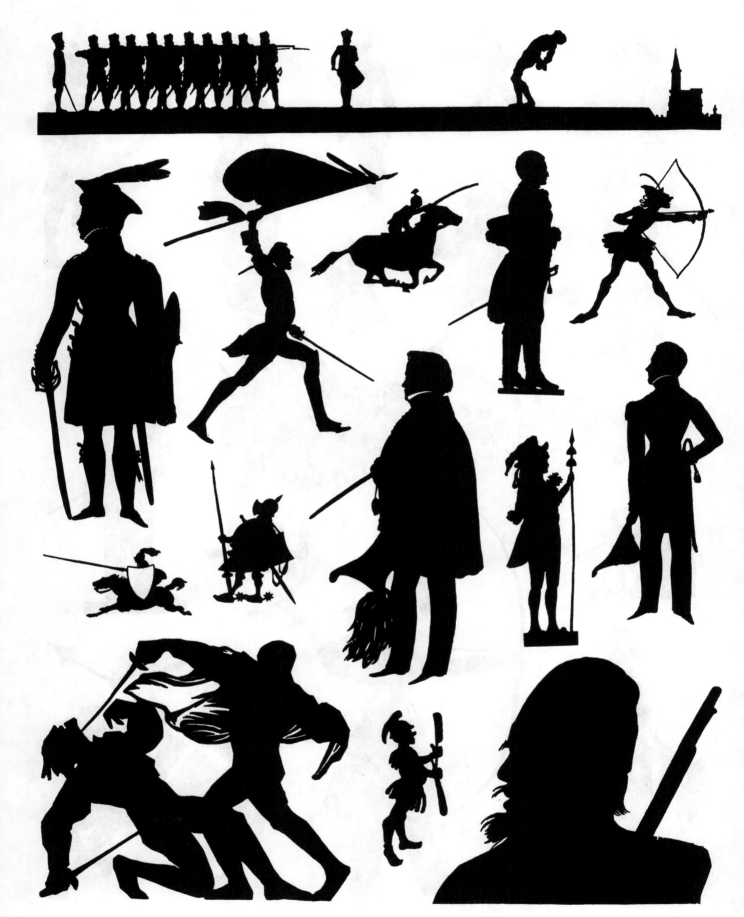

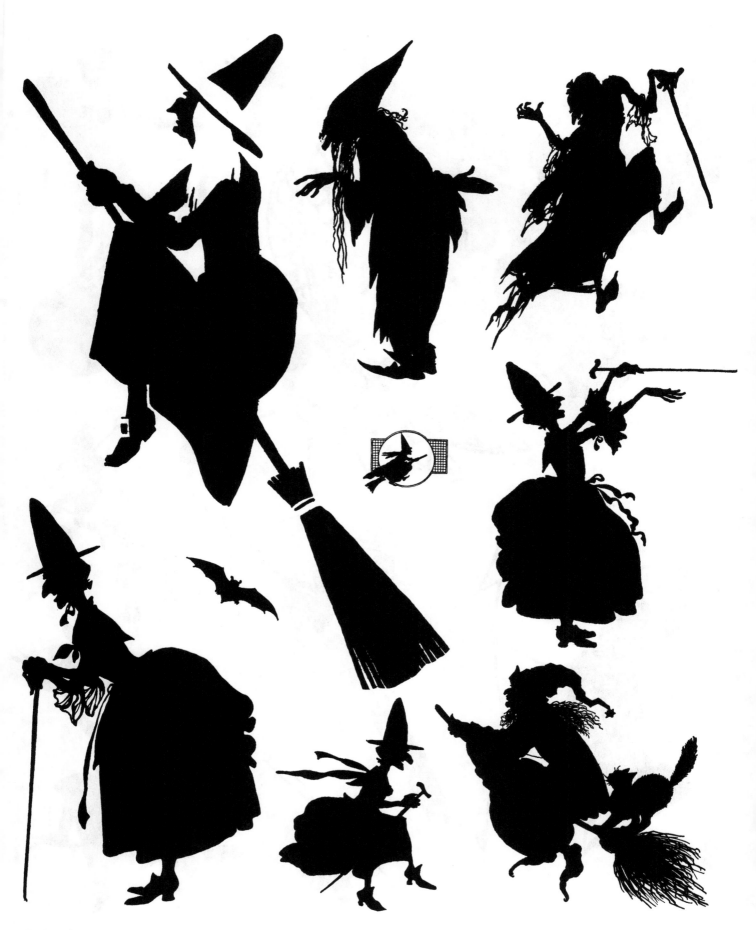

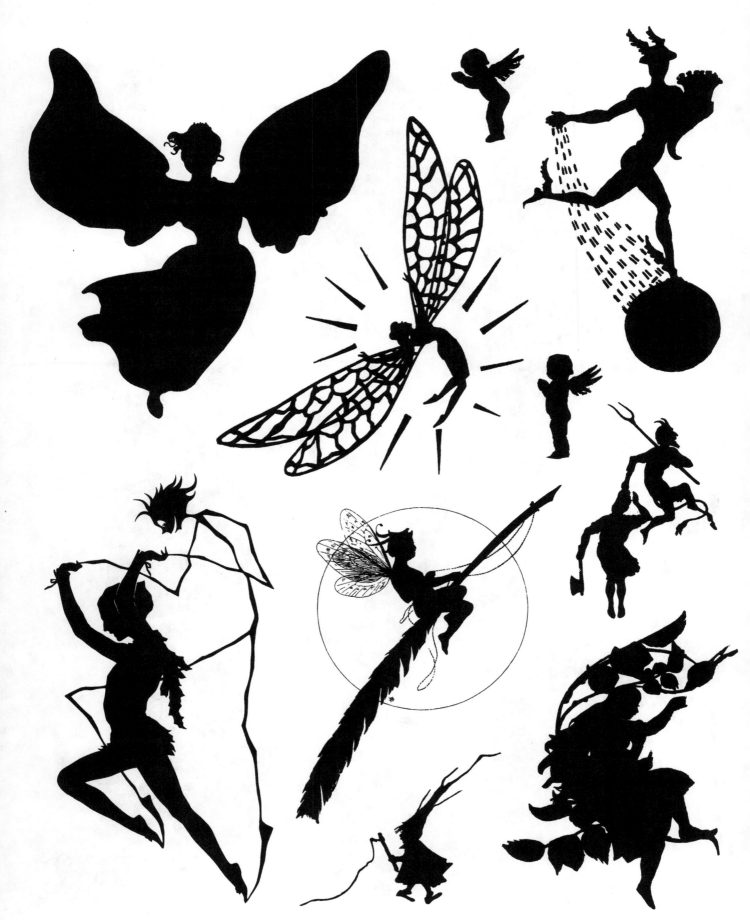

Printed in the USA
CPSIA information can be obtained
at www.ICGtesting.com
LVHW080755201023
761554LV00012B/241

9 780486 407012